# Adoration Quilts

## Appliqué Nativity Projects

### RACHEL W. N. BROWN

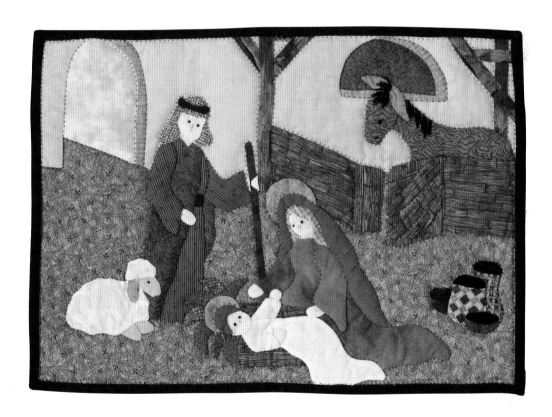

*Martingale*®
& COMPANY

Adoration Quilts: Appliqué Nativity Projects
© 2006 by Rachel W. N. Brown

That Patchwork Place® is an imprint of Martingale & Company®.

Martingale & Company
20205 144th Avenue NE
Woodinville, WA 98072-8478 USA
www.martingale-pub.com

Printed in China
11 10 09 08 07 06   8 7 6 5 4 3 2 1

**Library of Congress Cataloging-in-Publication Data**

Library of Congress Control Number: 2006002724

ISBN-13: 978-1-56477-670-9
ISBN-10: 1-56477-670-0

## Mission Statement
Dedicated to providing quality products and service to inspire creativity.

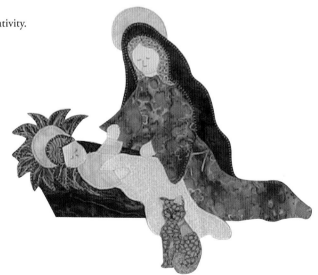

## Credits
President: *Nancy J. Martin*
CEO: *Daniel J. Martin*
COO: *Tom Wierzbicki*
Publisher: *Jane Hamada*
Editorial Director: *Mary V. Green*
Managing Editor: *Tina Cook*
Technical Editor: *Darra Williamson*
Copy Editor: *Sheila Chapman Ryan*
Design Director: *Stan Green*
Illustrator: *Robin Strobel*
Cover and Text Designer: *Trina Craig*
Photographer: *Brent Kane*

## Dedication

To my family

To my husband, Dennis:

Without his encouragement over the past 38 years, I would not understand my faith and my creativity as the gifts they have become. He has been willing to sacrifice career moves so that I could follow my dream, and I am deeply grateful.

To my children: Dara Lynn; Catherine Estelle; Gregory Micah Enten; and Kristine Elizabeth, my "extra" daughter, whom I consider one of my own:

As each of them entered our lives, we longed to help them make sense of an increasingly secular holiday season; it was out of that need that many of our family traditions evolved. The many wonderful family memories that surround the sacred holiday came from an effort to help our children understand and enjoy this special time beyond its commercial trappings.

Dara Lynn is married to Tim Wilson; they live in Booneville, Arkansas.

Catherine (Kay) is married to Travis Shirey; they live in New Hope, Virginia.

Greg, 10 years younger than his sisters, lives in Staunton, Virginia.

Kristy is married to Steve Walker; they live in Millboro, Virginia. I am "Nana Rachel" to their daughters, Brittany Kay and Rachel Marie.

As adults, my children continue to bless my life in so many wonderful ways.

For the delightful holiday memories we share, and continue to make together, I am grateful beyond the mere expression of these words.

## Acknowledgments

WRITING THIS BOOK and creating the projects have not been solitary efforts. So many people have helped and encouraged me along the way.

My wonderful employees, present and past, who bless me with their encouragement and inspiration. They are devoted employees and special friends. We are "Sisters of the Cloth." My employees have worked extra hours and covered for me so that I could concentrate on getting these projects into book form. As I neared deadlines, they helped with last-minute details. *Present:* Cathy Thornton, Susan Shiflet, Cece Altomonte, Dianne Louvet, Kay Shirey, Susan Shover, and Molly Cook. *Past:* Missy Barnhart, Cheryl Rosberg, Sandy Hurlbut, and Sarah Walker.

To Anita Cook, for stepping beyond friendship and taking up her green correcting pen. She spent many hours helping me edit the final manuscript. I appreciate her knowledge of our English language.

To the "extras" who stepped in to help: Michael Louvet, for sorting out sines and tangents as we designed the tree-skirt pattern; Lisa Byers, for cutting and fusing and hours of blanket-stitching on her trusty sewing machine; and Anna Davis and Anne Bell, for their help with whatever needed to be done at the moment.

I am blessed with wonderful girlfriends: Anita Cook; Ramona Pence; Nadene Brunk; Mary Cline; Jan King; Tara Hornbacker; Beverly Harp; and my sisters, Merti Brubaker, Debbie Mosimann, and Joanna Huacani. Some are quilters; some are not. All are artists of the Spirit, who encourage me every step of the way on my journey. They are my confidants and my listening ears. They laugh with me, cry with me, pray with me, and cheer me on. Thank you all.

I deeply appreciate the opportunity to share this book through Martingale & Company, with special thanks to Karen Costello Soltys, Tina Cook, Terry Martin, and Darra Williamson, who patiently worked with me and gently guided me through the process of preparing my first manuscript for publication.

# Contents

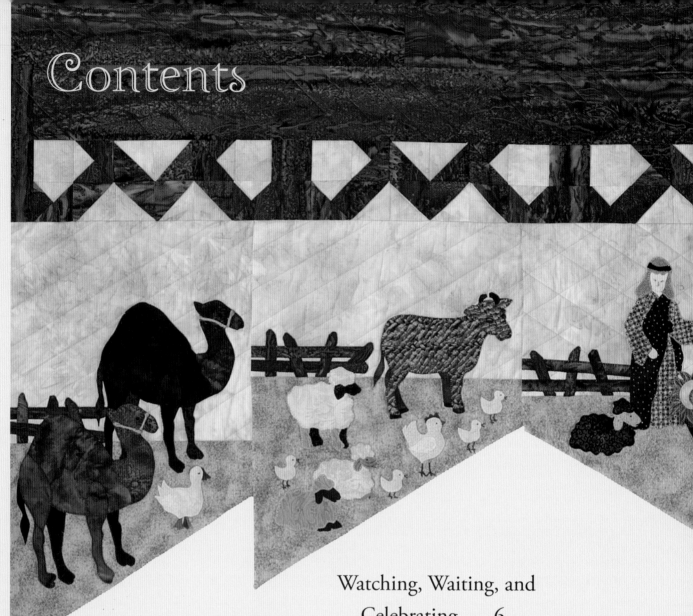

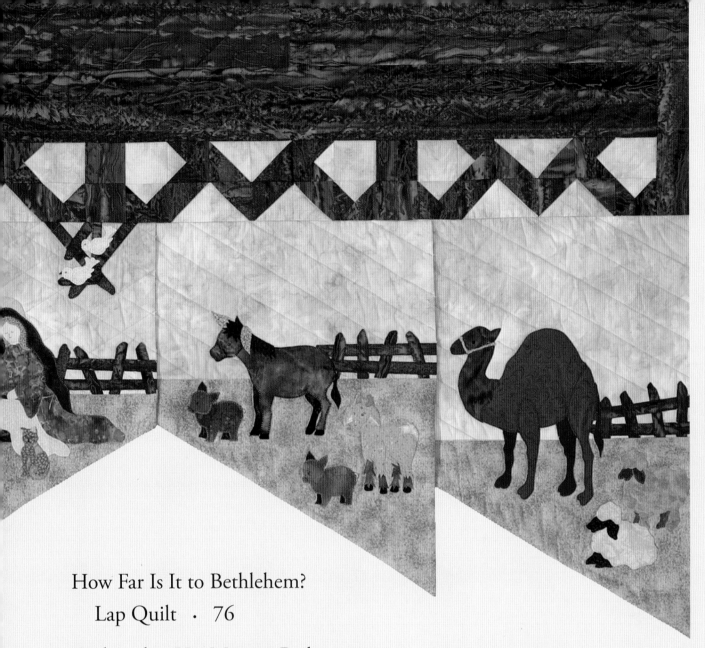

# Watching, Waiting, and Celebrating

I LOVE THE CHRISTMAS SEASON. So much about this time of year brings me joy. There is the sacred story of a young woman of faith, her obedient carpenter fiancé, the infant in a manger, angels, shepherds, starry skies, travelers from far away, and gifts—gifts of love, hope, peace, joy, and comfort, all wrapped up in grace. Over the years, I've gathered stories and traditions that are rooted in the sacred stories I learned in my childhood home and in Sunday school. I've always been fascinated as well by the secular traditions that have grown around this holiday season.

When I opened Rachel's Quilt Patch in 1997, many quilt shops were introducing block-of-the-month programs. We decided to work at creating one of our own. After several fits and starts, the block-of-the-month program for "The Adoration" was born. Missy Barnhart (a former shop employee) and I brainstormed until the format was set, and I filled in the artistic details. From our collections of children's books and stories, family traditions and rituals, coworker Susan Shiflet and I gathered our favorite tales and legends—those that would go with the characters of the nativity. In time, "The Adoration" project grew into a truly unique quilting experience. The kits sold, and soon my employees began to talk about how to market the pattern for the entire wall hanging. At the time, we all decided it would make a wonderful book. Several years later, I reworked the manuscript, designed six more projects, and got up the courage to submit the package to Martingale & Company. The result is this book.

I hope you discover in this book the joy we found in creating the projects and in gathering the information and resources. I share with you not only the projects and their instructions, but theme-related stories and suggestions, books for children, and Christmas traditions and legends from around the world.

For my family, the Christmas holiday season begins the first Sunday of Advent, and continues through Epiphany, the Twelfth Day of Christmas. The season is a grand combination of traditions we have developed over the years, both secular and sacred. I hope you, too, will find the best mix of all that is Christmas to make the holiday meaningful every year.

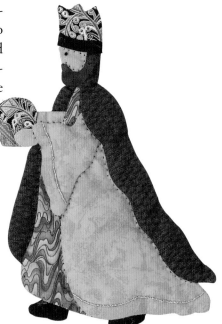

# General Instructions

ON THE FOLLOWING PAGES, you'll find information and ideas that I've gleaned over the years from taking classes, talking with quilters, and from my own experiences and discoveries. I'm including several techniques I've developed that help me get the look I want in my quilting projects, as well as methods and information specific to the blocks and projects in this book. Read through these pages before you begin any project and refer to them as needed as you work.

## Appliqué Techniques

THE FOLLOWING TECHNIQUES will help you create the various blocks and projects in this book.

### Plastic-Template Appliqué

My favorite way to prepare appliqué pieces for hand and machine blind-stitch appliqué is with heat-resistant plastic template sheets. Plastic templates allow me to work with especially small pieces and to handle pieces with small, smooth curves.

For this technique, you will need:

- Heat-resistant template plastic. (Be sure that you're purchasing *heat-resistant* template plastic.) The "frosty" type is easier to work with than the clear, shiny plastic.
- A permanent, extra-fine-line marking pen
- Light spray starch or spray sizing
- Chalk marking pencils
- A small saucer
- A dry iron. I use my mini iron.
- A ½" or smaller stencil brush (optional)

Here's how the method works:

1. Trace the pattern piece onto the plastic template with a permanent, extra-fine-line marking pen.

2. Mark the right side of the pattern piece with the name of the piece: *robe, face,* or *cloak,* for example. Cut the template out on the marked line (fig. 1).

3. Place the template, *right side down,* on the wrong side of the fabric.

### Freezer-Paper Appliqué

If you wish, you can substitute freezer paper for the plastic template. Some quilters prefer to thread baste the seam allowance under rather than pressing it under with the iron.

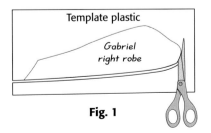

Template plastic

*Gabriel right robe*

**Fig. 1**

4. Trace around the template with a chalk pencil that shows easily on the fabric (fig. 2). Cut out the piece, adding a ¼" seam allowance all around (fig. 3).

5. Spray enough starch or sizing into a saucer to make a small puddle. Dip your index finger into the starch and lightly dampen the edges of the right side of the fabric piece. As an alternative, you can use a small stencil brush.

6. Replace the plastic template on the wrong side of the cut fabric shape. Working 1" at a time, gently press the seam allowance over the edge of the template using the tip of a dry iron (see "Temperature Test" at right). Be sure the section you're pressing is completely dry before you move on. If the remainder of the piece dries before you finish pressing, dampen it again with a little more starch (fig. 4).

7. Press under all edges that will be stitched (fig. 5). You don't need to press those edges that will be covered by another piece. Carefully remove the plastic template, touching up the pressed edges with an iron as needed.

**Fig. 2**

**Fig. 3**

**Fig. 4**

### Freezer-Paper Landscape Appliqué

I've developed a technique similar to plastic-template appliqué that uses freezer paper for larger pieces, especially landscape pieces. I discovered this method when I was looking for an easy way to get multifabric landscape backgrounds to look as though I had drawn them.

For this technique, you will need:

- A piece of muslin
- Your favorite marking tool
- Freezer paper
- Scissors for cutting paper and fabric
- A dry iron
- Light spray starch or spray sizing
- A small saucer

**Fig. 5**

Here's how the method works:

1. Cut a muslin foundation as described in "Backgrounds Cut from a Single Fabric" (page 21), substituting the muslin for the background fabric.

2. Trace the landscape lines from the block pattern onto the muslin (fig. 6).

3. Letter the landscape pieces in the order they will be placed, beginning with the piece that appears the farthest away (fig. 7). Usually this means you'll start at the top of the design.

4. Trace the first landscape piece onto the paper side of a sheet of freezer paper. Cut out the freezer-paper shape, adding a ½"-wide seam allowance.

**Fig. 6**

**Fig. 7**

**Fig. 8**

5. Iron the freezer-paper shape onto the *right* side of the fabric you've chosen for this landscape piece. Carefully cut along the edges of the freezer paper so the fabric piece is the exact same size and shape as the template. Peel off the freezer paper and pin the fabric piece onto the muslin in the position you've designated as position *A* on the landscape. Mark the placement line for the second piece by overlapping the bottom edge of the previous piece ½" (fig. 8).

**Fig. 9**

6. Repeat steps 4 and 5 to trace and cut the second landscape piece. Remove the freezer paper. Cut away the seam allowance on the *top* edge of the freezer-paper template after it's been removed (fig. 9).

**Fig. 10**

7. Iron the freezer paper back onto the right side of the fabric piece, lining up the template and fabric at the bottom edge. This leaves the top seam allowance free. Clip any curves halfway into the exposed seam allowance (fig. 10).

8. Spray enough starch into a saucer to make a puddle. Peel the freezer paper off the fabric; set the freezer paper aside. With your index finger, dampen the clipped edge of the fabric with spray starch.

Waxy side of freezer paper

**Fig. 11**

9. Place the freezer-paper pattern, waxy side up, on the wrong side of the fabric. With a dry iron, gently press the dampened seam allowance over the edge of the freezer paper (fig. 11). The seam allowance will stick to the freezer paper. Continue pressing until the seam allowance is dry and flat.

10. Carefully peel the freezer paper away and pin the second piece to the muslin foundation (fig. 12). Repeat steps 4–9 until you have prepared all the landscape pieces.

**Fig. 12**

11. Use a hand or machine blind stitch to appliqué each piece to the muslin foundation. Carefully cut away the muslin from behind each piece, leaving a ¼"-wide seam allowance (fig. 13).

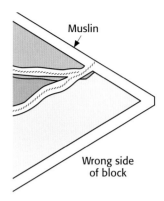

**Fig. 13**

### Fusible Appliqué

FUSIBLE APPLIQUÉ IS a quick and neat way to appliqué if you're in a hurry or if you're making a piece that will be handled frequently. Most projects in this book are made using a lightweight fusible product, with the appliqué edges finished with a machine blanket stitch. Be sure to buy a fusible product designed specifically for sewing.

For this technique, you will need:

- A roll of parchment paper, available at your local grocery store near the freezer paper
- A permanent marking pen, such as a Sharpie, with a fine point (*not* ultra-fine)
- A lightweight fusible web designed for sewing
- Scissors for cutting fusible web and fabric
- A dry iron
- A non-stick pressing sheet

For the fusible method, you'll need to trace the pattern pieces *in reverse* before you transfer them onto the fusible web. A parchment-paper pattern eliminates some of the hassle.

Here's how the method works:

1. Place a piece of parchment paper over the figure you want to copy. Trace all the pieces of the figure onto the paper. You'll be able to see the pattern from both sides of the parchment paper. Label the front side as the right side of the pattern (fig. 14).

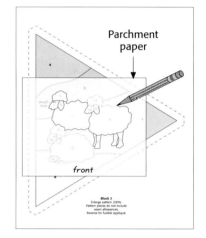

**Fig. 14**

2. Turn the parchment pattern over and place the fusible web, *paper side up,* on the pattern. Trace the individual pattern pieces onto the fusible web. If you can't see the lines clearly enough, slide a blank sheet of white paper underneath the parchment pattern. Label the pieces according to their name (sheep's body, sheep's head, etc.) or their number (fig. 15).

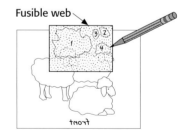

**Fig. 15**

### Keeping Organized

I find it easier to work with one figure at a time. A labeled sandwich bag works well for keeping the pieces for each figure together until I am ready to appliqué.

## Finishing with Alternative Stitches

I use a blanket stitch to secure the edges of the appliqués, *except* on some very small pieces, where I use a straight stitch instead. If your sewing machine doesn't have a blanket stitch, you can substitute a straight stitch or a narrow zigzag stitch. I prefer not to make a satin stitch but rather to leave space between the stitches.

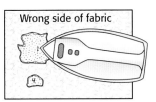

**Fig. 16**

3. Roughly cut each pattern piece out of the fusible web. Use a dry iron to press the fusible web piece to the *wrong* side of the appropriate fabric (fig. 16).

4. Cut out the pattern pieces directly on the traced lines, *except* for any edges that will be covered by another piece. Cut these edges ⅛" beyond the pattern line. Once again, label each piece by its name or number (fig. 17).

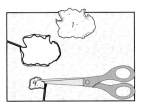

**Fig. 17**

5. Place the parchment pattern right side up on the ironing board. Place the pressing sheet over the pattern. You may need to place a blank sheet of white paper under the parchment to help you see for this step as well.

6. Peel the paper backing from each piece. Carefully assemble the figure on the pressing sheet, overlapping the pieces as needed. When you're satisfied, press all the pieces in place to create one fused unit. Allow the assembled piece to cool before peeling the complete figure off the pressing sheet (fig. 18).

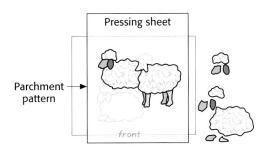

**Fig. 18**

7. Position and press the assembled figure in place on the background, making sure the pieces are secure.

8. With thread to match each fabric, and using the blanket stitch on your sewing machine, stitch each appliqué shape to the background.

## Managing Multiple Pieces

When I assemble a figure that includes a lot of pieces, I fuse small units first and then assemble smaller units into the whole figure. For example, I fuse the face, hair, and halo of an angel as one unit, the hand and sleeves as another, and so on. When the individual units have cooled, I peel them from the pressing sheet and assemble all the parts.

## Embroidery Stitches

I used a few simple embroidery stitches (at right) to embellish some of the appliquéd blocks. Feel free to add your favorites as well.

## Adding Borders

When you're ready to add borders, measure the quilt top through the center, both lengthwise and crosswise. This assures that the sides of your quilt will be straight and the corners square. Use these measurements when you cut your borders.

You'll need to decide if you want to finish your borders with squared or mitered corners. I like the finished look of a mitered corner, so while I usually square my inner borders, I prefer to miter my outer borders.

Yardage and cutting instructions for the outer border in each project provide enough fabric to miter the corners of your quilt if you choose. If you would rather square the outer border as well as the inner border, follow the directions for adding squared borders.

### Squared Borders

To add squared borders to your quilt:

1.  Measure the length and width of your quilt top through the center and make a note of these measurements.

2.  Cut two borders to the measured *length* of the quilt. Find and pin-mark the midpoint of each border and the sides of the quilt (fig. 19). Starting from the midpoint, pin the borders to the sides of the quilt. Sew the borders to the quilt and press the seams toward the border.

3.  Add twice the cut width of the border minus ½" to the *width* measurement you noted in step 1. Cut two borders to this measurement and refer to step 2 to sew these borders to the top and bottom of the quilt; press (fig. 20).

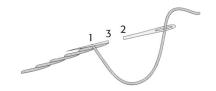

Stem or outline stitch

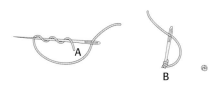

French knot

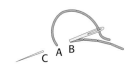

Backstitch

Loopy fringe.
Wind floss around a
1" cardboard square.

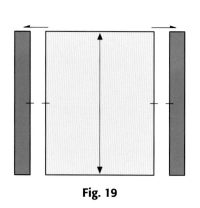

**Fig. 19**

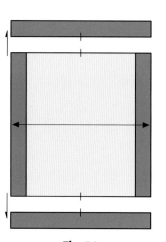

**Fig. 20**

## Mitered Borders

MITERED CORNERS REQUIRE longer border strips than squared corners. To find the measurement of each border piece:

1. Measure the *length* of your quilt through the center. To this measurement, add twice the finished width of your borders plus 4" for insurance. For example, if the length of your quilt is 60" and your borders will finish 6" wide: 60" + 12"(2 x 6") = 72"+ 4" = 76". For this quilt, you would cut two border strips, each 6½" x 76".

2. Repeat step 1 to measure the width and cut borders for the top and bottom of the quilt.

3. Find and pin-mark the midpoint of each side border (fig. 21). Divide the *length* measurement of the quilt top in half, measure this distance from both sides of the center pin on the side border strips, and pin-mark these points as well.

4. Pin the side borders to the sides of the quilt, using the pins as reference (fig. 22).

5. Stitch the borders to the quilt, stopping and starting ¼" from the pinned ends (fig. 23). Open the borders but *do not* press the border seams.

6. Repeat steps 3–5 to pin-mark, pin, and sew the borders you measured and cut in step 2 to the top and bottom of the quilt. The stitching should meet the stitching from the previously sewn borders at each corner, leaving the last ¼" free (fig. 24).

7. Place the quilt face up on a worktable with one corner close to you. Flip one border right side together with the quilt top. Place the adjacent outer-border piece underneath and perpendicular to this border (fig. 25).

8. Place your ruler on the border, aligning the 45° mark on the ruler with the cut edge of the border as shown. Mark along the edge of the ruler so that the line you draw meets the stitching at the inner corner of the quilt top (fig. 26). This will be your stitching line (fig. 27).

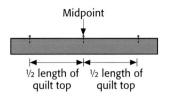

**Fig. 21**

**Fig. 22**

**Fig. 23**

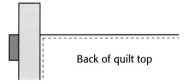

**Fig. 24**

**Fig. 25**

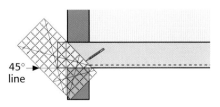

**Fig. 26**

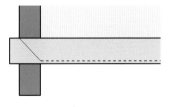

**Fig. 27**

9.  Place the marked border right sides together with the adjacent border, aligning the raw edges. The quilt top will fold on a 45° angle. Pin carefully on the marked line (fig. 28).

10. Using a backstitch and starting from the outside edge of the border, stitch directly on the marked line to the corner of the quilt, stopping with a backstitch at the corner seam (fig. 29).

11. Trim the excess border fabric, leaving a ½"-wide seam allowance (fig. 30). Press the seam open (fig. 31). Repeat for all four corners. When you've finished, press the long seams toward the newly added border.

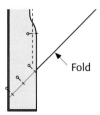

**Fig. 28**

**Fig. 29**

**Fig. 30**

**Fig. 31**

## Finishing Your Quilt

ONCE YOUR QUILT top is complete, it's time for the finishing steps, which include basting, quilting, and binding.

### Backing and Batting

CHOOSE A BACKING fabric that complements the quilt. Some quilters like to use a fabric that appears in the quilt top for the backing. Remember that the binding will be turned and stitched to the back of the quilt, so you may want to use a fabric that coordinates with the binding as well.

I usually don't choose the backing until the quilt top is finished. I like pretty backs, and I like to see color on the back of my quilts. The perfect backing fabric may cost a little more, but I feel it is worth it. Backing should measure at least 3" larger than the quilt top on all sides, so you may need to piece the backing fabric if the quilt is larger than the width of the fabric.

Use good-quality batting. You've bought good fabric and put your valuable time into the project. Don't skimp on cheap batting. If I'm machine quilting, I use cotton or cotton-blend batting. If I'm hand quilting, I use a very low-loft polyester batting. The batting should measure at least 1" larger than the quilt top on all sides.

### Layering and Basting

LAYER THE QUILT by placing the backing wrong side up on a table or other clean, flat surface. Smooth it so that it lies completely flat. Tape the edges at several places to keep the backing in place. Center the batting on top of the backing, fluffing it and patting it out until it's completely flat, and then center the quilt top on the batting. Pin the layers together around the edges with straight pins.

If you're machine quilting, baste with #1 or #2 safety pins. If you're hand quilting, thread baste in a grid with lines of stitching no more than 4" or 5" apart.

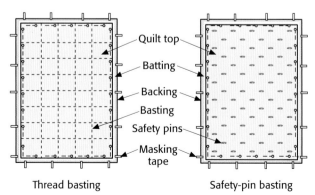

Quilt top
Batting
Backing
Basting
Safety pins
Masking tape

Thread basting            Safety-pin basting

## Quilting

How you quilt your project depends on several factors. If you have hand pieced and/or hand appliquéd the top or you anticipate that the quilt will become an heirloom, then I would definitely recommend that you hand quilt it, or pay someone to hand quilt it for you. If, on the other hand, you have made a quilt for your son to take to college, then machine quilting is the way to go. Similarly, if the quilt has lots of different fabrics and lots of seams, hand quilting will be lost in the pattern of the fabrics, so I suggest you machine quilt it. Many of us love to piece, and have more quilt tops than we can hand quilt in a lifetime—and I'm well past the middle of my lifetime. I send my quilts to the machine quilter and head without guilt into my next quilt project.

For detailed information about hand quilting, refer to *Loving Stitches: A Guide to Fine Hand Quilting, Revised Edition* by Jeana Kimball (Martingale & Company, 2003). If you prefer machine quilting, you'll find a wealth of information in *Machine Quilting Made Easy!* by Maurine Noble (Martingale & Company, 1994).

## Binding

When the quilting is finished, it's time for binding. The binding can be cut on the straight of the grain or on the bias. I prefer a bias binding, especially on a quilt that will be used a lot. I think bias bindings wear better than straight-grain bindings. The yardages given with each project in this book are enough for you to make bias bindings if you wish.

1. With thread to match the border fabric, hand baste around the outside of the quilt with a small basting stitch, ⅛" from the edge. This keeps the border layers from shifting as you sew on the binding. Trim the edges of the batting and backing even with the quilt top.

2. Measure and total all four sides of the quilt to find its perimeter (outside measurement). Add 9" to this measurement; this equals the number of inches of binding you'll need for your quilt. If you prefer to work in yards, divide the total by 36".

3. Cut the binding fabric on the bias into enough 2½"-wide strips to total the length of binding you need. Sew the strips together on the diagonal with ¼" seams. Trim the seams and press them open (fig. 32).

**Fig. 32**

### Plan Ahead for Binding

Very often, I use the same fabric for binding as I use for the outer border of my quilt. I like to cut my outer borders on the straight of the grain without any seams, so I buy border fabric equal to the length of my quilt, plus ¼ yard (9"). From this yardage, I can cut borders up to 7" wide, and use the fabric left to make the binding.

4.  Fold the binding in half, wrong sides together; press. Trim the leading end of the binding at a 45° angle and fold under a ¼" seam allowance (fig. 33).

**Fig. 33**

5.  Align the raw edges of the binding with the raw edges of the quilt top and, leaving a 3" tail at the beginning as shown, begin sewing the binding to the quilt at the center of the bottom border using a ¼" seam. Stop sewing ¼" from the first corner; backstitch (fig. 34).

6.  Fold the binding so it creates a 45° fold at the corner as shown (fig. 35).

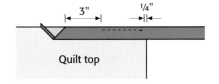

**Fig. 34**

7.  Fold the binding down, aligning the raw edges of the binding with the adjacent border. Ease the top layer of the binding ⅛" above the top edge of the quilt as shown. Take a backstitch and begin stitching a scant ¼" from the folded edge of the binding (fig. 36). Repeat for all four corners as you come to them.

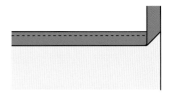

**Fig. 35**

8.  Stop sewing about 3" from the starting end of the binding. Trim the end of the binding to extend 3" beyond the folded starting end. Tuck the trimmed end of the binding into the fold and pin in place. Finish sewing the binding to the quilt (fig. 37).

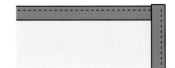

**Fig. 36**

9.  Fold the binding to the back of the quilt and hand or machine stitch in place (fig. 38). Pay particular attention to the corners, folding over first one side and then the other to create a miter (fig. 39).

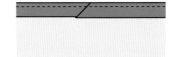

**Fig. 37**

### Adding a Label

Don't forget to label your quilt when it's finished. Include information about who made the quilt and whom it's for (if it's a gift). I like to add dates and relevant places, too. If others have helped with the quilt, give them credit, especially if they have quilted the piece for you.

By the time I finish a quilt, I'm not always in the mood to do a lot of fancy drawing for the label. I choose a decorative font on my computer instead, and enlarge the font so that it can be easily read. I print it out and iron a piece of freezer paper to the back of my label fabric. With a Pigma pen, I trace the wording onto the fabric. (A light box helps here.) I add cutouts of fabric motifs from the quilt top or other related prints to add character to the label. (Sometimes I buy a fabric because I see potential in it as a label.) I fuse the motifs in place and blanket-stitch or straight stitch around them. Finally, I turn under the edges of the label and blindstitch it to the back of the quilt.

Sometimes I use a leftover appliqué shape, or one that I cut facing the wrong way or that did not show up well on the background block. I fuse the appliqué shape in place on a piece of fabric. I stitch around it with a blanket stitch, write the documentation information on it, and stitch it to the back of the quilt.

Fold first.

Quilt back

Fold second.
**Fig. 38**

**Fig. 39**

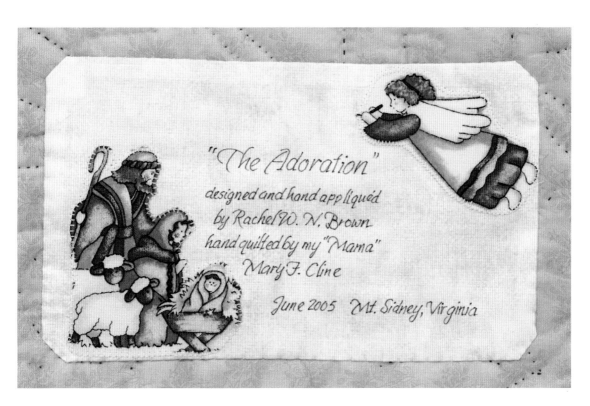

*The label for "The Adoration" (page 18)*

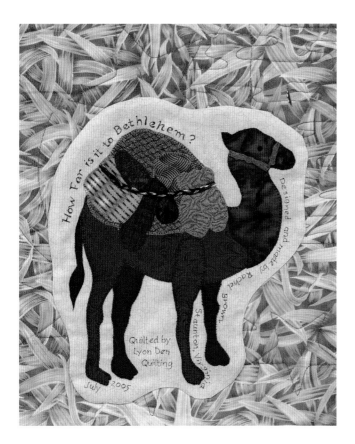

*The label for "How Far Is It to Bethlehem?" (page 76)*

# The Adoration

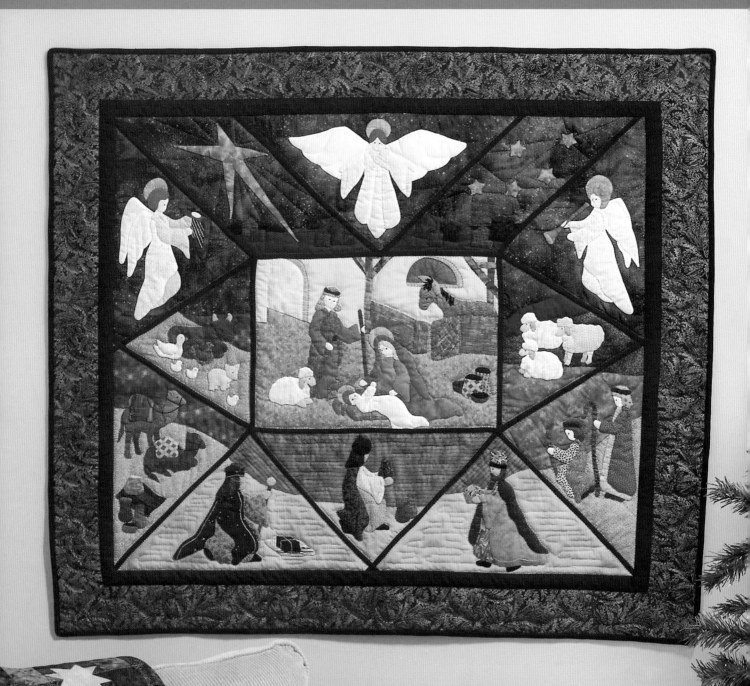

*Hand pieced and appliquéd by Rachel W. N. Brown,*
*50" x 45". Hand quilted by Mary F. Cline.*

It is said that at Christmastime, all roads lead us to the manger in Bethlehem. With a sense of excitement and wonder, we prepare for the celebration of the birth of a very special child. In this wall hanging, all the blocks gather around the manger block, which causes us to focus on the holy family in the humble stable nursery. We share with the angels, shepherds, and Magi the adoration of the Christ child.

## Making the Wall Hanging

FABRIC REQUIREMENTS ARE listed in the order you'll need them, but simply refer to the pages listed below if you'd like to gather all your fabrics at once. Putting "The Adoration" together is a four-step process.

1. Make the base (below through page 21).
2. Gather fabrics for the block backgrounds (page 22).
3. Choose fabrics for and then appliqué each block (pages 24–62).
4. Gather materials for borders, backing, batting, and binding (pages 63–64) and then assemble the quilt.

## Making the Base

BEFORE YOU BEGIN to make the blocks (pages 22–62) for "The Adoration," you'll need to make a base. The base acts as a roadmap for the project and serves two purposes. Firstly, the base establishes the shapes for the individual blocks, and you'll trace the shapes from the base onto freezer paper to make templates or onto muslin to use as foundation for the block backgrounds. Secondly, when you finish the blocks, the base becomes the map for positioning the blocks and assembling the quilt.

Except for the rectangle in the center, the blocks are nontraditional in shape. The opposite sides of the quilt are mirror images, but the triangle- and parallelogram-shaped blocks have a definite top and bottom.

To make the base, you will need:

- 1 yard of 50"-wide tear-away stabilizer
- 6" x 24" ruler
- Fine-line Sharpie pen

If you're unable to find 50"-wide stabilizer, you can piece together several lengths to achieve the dimensions needed. This is not a permanent part of the wall hanging.

### Storage Solution

When I begin a project that may not be completed right away, I buy a plastic storage box. As I trace patterns and collect fabric, I put everything related to the project in one box. When I prepare binding or finish a block, it goes in the box. When I am ready to put the project together, everything I need is in one place.

Here's how to make the base:

1.  Measure and cut the stabilizer to measure exactly 35" x 40". Measure 1" in from the edge of the stabilizer on all sides and draw a large rectangular block as shown. Write *top* along one 40" side of the drawn block (fig. 1).

2.  Measure and mark the center of all four sides of the rectangular block you drew in step 1. Measure 10" in from the large block on all sides and draw a second, smaller block with sides parallel to the larger block as shown. The smaller block should measure 13" x 18" (fig. 2).

3.  Draw a line from the corners of the inner block to the corners of the outer block as shown (fig. 3).

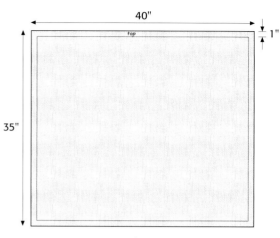

**Fig. 1**

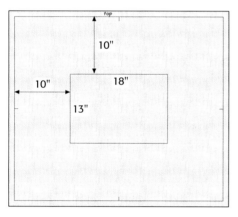

**Fig. 2**

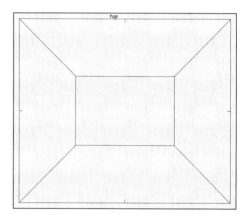

**Fig. 3**

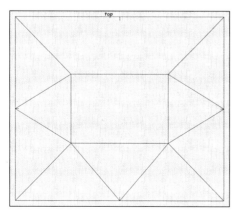

**Fig. 4**

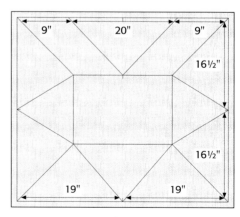

**Fig. 5**

4. Draw a line from the midpoint of the left side of the large block to the nearest corners of the small block as shown. Repeat on the bottom and right side (fig. 4).

5. Measure and mark 9" in from each top corner of the large outer rectangle. Measure and mark the midpoint of the top of the small inner rectangle. Connect the points as shown (fig. 5).

6. Label each section with the number, grain-line placement, and direction *(top, bottom, left,* or *right)* as shown (fig. 6).

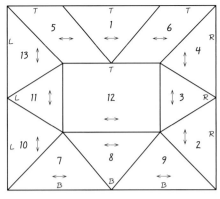

**Fig. 6**

## Preparing the Background Blocks

SOME BACKGROUND BLOCKS are cut from a single fabric. Others are made from multiple fabrics layered and appliquéd over a muslin foundation.

**Backgrounds Cut from a Single Fabric**
These are blocks 1, 4, and 13.

1. Trace the appropriate block from the base onto the paper side of freezer paper. Use a ruler to add ½" to each side of the shape. Cut out the paper shape on the outer line; or, if you prefer, trace the block patterns that appear with each block. These patterns include the ½" seam allowance. Label or number the freezer-paper template and mark the grain line, the top, and/or any other key side of the block (fig. 7).

2. Iron the freezer-paper template, waxy side down, to the right side of the background fabric. Carefully cut along the edges of the freezer paper so the fabric piece is the exact same size and shape as the template (fig. 8). Remove the freezer paper and set it aside in a safe place. You'll use it later, in the final assembly of the wall hanging.

**Fig. 7**    ½"

**Multifabric Backgrounds Appliquéd on Muslin**
These are blocks 2, 3, 5, 6, 7, 8, 9, 10, 11, and 12.

Repeat the process described in "Backgrounds Cut from a Single Fabric" (above), substituting muslin for the background fabric. The layered landscape technique is described in "Freezer-Paper Landscape Appliqué" (page 8).

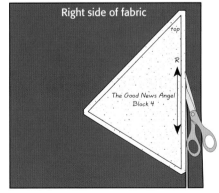

**Fig. 8**

# MAKING THE BLOCKS

THE LIST BELOW outlines the background fabrics you'll need for "The Adoration." Refer to this list as you construct each block. The list gives the total yardage needed to make the backgrounds as I have. Feel free to use as many different fabrics within the color range as you wish. If you're starting from scratch, the yardage is more than adequate. If you have a stash, my theory is the more fabrics the merrier. Shop with a friend and buy enough to share. (Fabric requirements for the figure appliqués are listed in the specific block instructions.)

## Materials for the Block Backgrounds

- ¾ yard of night-sky fabric for blocks 1, 3 (A), 4, 5 (A), 6 (A), 11(A), and 13
- 1 yard of muslin for base of blocks 2, 3, 5, 6, 7, 8, 9, 10, 11, and 12
- Fat quarter of light-medium green print for grass in block 2 (C)
- Fat quarter of medium to bright green print for grass in blocks 2 (B) and 3 (D)
- 5" x 10" piece of dark green print for grass in blocks 2 (A) and 3 (C)
- 4" x 10" piece of brownish green for hill in block 3 (B)
- 3" x 5" piece of black print for hills in blocks 5 (C) and 6 (B)
- 3" x 5" piece of brown print for hills in blocks 5 (B) and 6 (C)
- 3" x 5" piece of very dark green for foreground in blocks 5 (D) and 6 (D)
- Fat quarter of light green solid for foreground in blocks 7 (B), 8 (B), and 9 (B)
- Fat quarter of medium green print for background in blocks 7 (A), 8 (A), and 9 (A)
- 10" x 13" piece of light brown fabric for foreground in block 10 (B)
- Fat eighth of green-and-brown print for background in blocks 10 (A) and 11 (B)
- 6" x 12" piece of tan print for foreground in block 11 (C)
- Fat quarter of medium cream print for walls in block 12 (A)
- Fat quarter of medium-light gold print for straw foreground in block 12 (B)

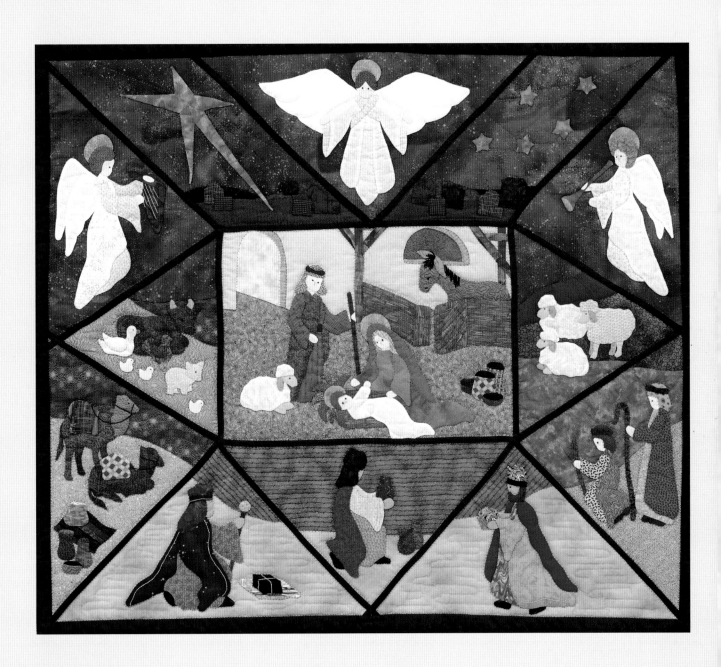

# BLOCK 1: GABRIEL

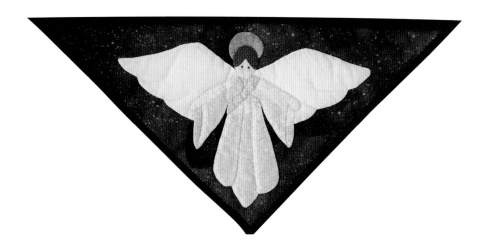

Although angels are mentioned more than 350 times in both the Old and New Testaments of the Bible, they are rarely given names. However, the special task of announcing the birth of the savior of the world to his virgin mother is given to an angel named Gabriel. The biblical account of this story is found in Luke 1:26–36.

This was not the first time Gabriel delivered amazing news; six months earlier he brought similar surprising news to Zechariah and Elizabeth about the coming birth of their son John the Baptist, even though Elizabeth was far past her childbearing years.

Angels are messengers, and Gabriel, whose name means hero of God, was the bearer of really good news. I am not at all sure that if I were the young Mary, I would have thought him much of a hero with the news he brought. However, I believe God knows humans better than we know ourselves. And God knew that Mary was the kind of devoted Jewish woman who would listen, learn, and be willing to do what she could to continue God's plan on earth.

> In the sixth month the angel Gabriel was sent by God to a town in Galilee called Nazareth, to a virgin engaged to a man whose name was Joseph, of the house of David. The virgin's name was Mary.
>
> **Luke 1:26–27** (New Revised Standard Version)

## Materials

The numbers in parentheses indicate the appliqué pieces as labeled on the pattern. In addition to the appliqué fabrics, you'll need the background fabric listed in "Materials for the Block Backgrounds" (page 22). Refer to "Making the Base" (page 19) and "Preparing the Background Blocks" (page 21) to prepare the background fabric.

- 9" x 9" piece of white fabric for wings (1 and 2)
- 6" x 8" piece of beige tone-on-tone print for robe (4, 5, 6, and 11)
- 3" x 4" piece of beige print for sash and sleeve lining (7, 8, 12, and 13)
- 2" x 3" piece of tan fabric for hands and face (9, 10, and 14)
- 2" x 3" piece of gold print for halo (3)
- 2" x 2" square of brown print for hair (15)
- White embroidery floss
- Black embroidery floss *or* black Pigma pen
- ¼ yard of lightweight fusible web (optional)

## Making the Block

Patterns for the Gabriel appliqué pieces appear on page 26.

1. Refer to "Appliqué Techniques" (page 7) or use your preferred method to prepare the Gabriel appliqué pieces (1–15). Working in numerical order, position and appliqué the pieces to the background fabric to complete the figure as shown on the pattern.

2. Refer to "Embroidery Stitches" (page 12) and to the photo (page 24). Use the white embroidery floss and a backstitch or outline stitch to add detail to the wings. Use the black embroidery floss to make small French knots for the eyes, or mark them with a black Pigma pen.

### A Hard-Working Angel

One of my favorite Christmas stories is a children's book by Julie Vivas titled simply *The Nativity* (see "Recommended Reading" on page 94). It's a book of wonderful watercolors illustrating the Luke account of the Christmas story. In one picture, a tattered-winged Gabriel, dressed in his work boots, is sitting at a table drinking a large cup of steaming coffee with a wide-eyed Mary. This is an angel with a big job to do; he takes his work seriously.

Our Gabriel has a more traditional look, and he represents the message that God will come to earth as a human baby, born to a young woman of faith. Gabriel brings the good news that this child will indeed change the world.

### Learning about Angels

You don't need to look very hard to find information about angels. There is an entire industry busy marketing angels. I don't walk through a shopping mall without seeing angels in the form of knickknacks and statues, as the subject of books, and as decoration for clothing. More than two-thirds of the American population believes that angels exist. I have several books about angels, and my favorite is *Celebration of Angels* by Timothy K. Jones (see "Recommended Reading" on page 94). Jones uses contemporary stories and biblical accounts of angel encounters to share an understanding of angels.

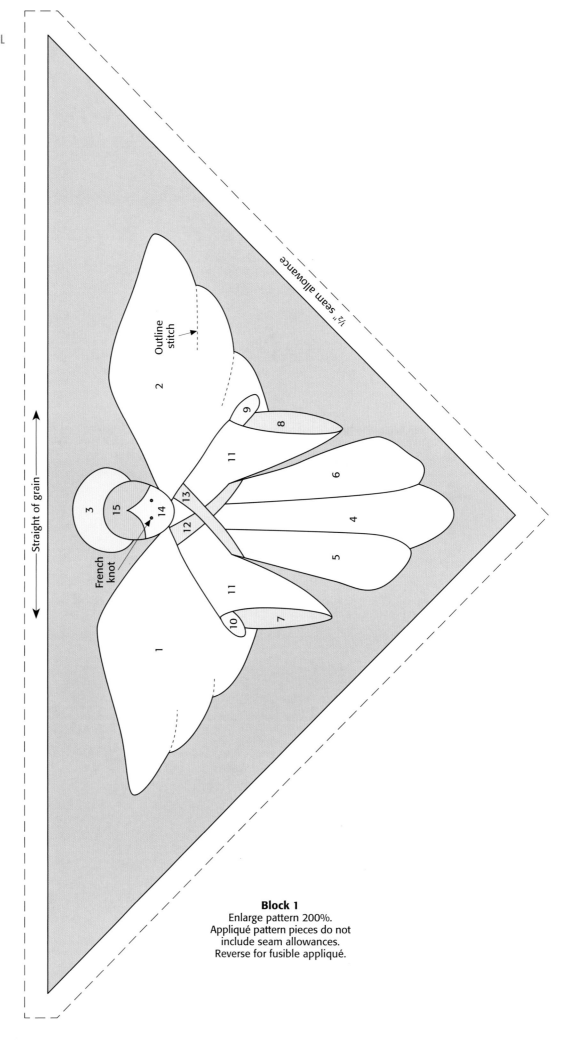

Outline
stitch

Straight of grain

½" seam allowance

French
knot

2

9

8

11

6

4

5

7

11

10

1

3

15

14

13

12

**Block 1**
Enlarge pattern 200%.
Appliqué pattern pieces do not
include seam allowances.
Reverse for fusible appliqué.

# BLOCK 2:
# THE SHEPHERDS

Those of us who have heard the Luke 2 narrative read or recited many times sometimes find ourselves following along word for word. Memories of Bible school or Sunday school return, recalling memory verses and awards won for learning this passage of the Luke scripture. On television, we hear Linus recite those words in "A Charlie Brown Christmas," and we discover through the Peanuts gang the real meaning of Christmas.

The artist's view of the shepherds often depicts them as much more beautiful than they actually were. These men were roughly dressed and poorly fed, and did not own the flocks they watched. One theory identifies shepherds as the poorest of society, whose job it was to take care of someone else's property. At the manger, they represent the poor among us.

Another theory holds that shepherds were really quite rough characters—rogues and ruffians fighting among themselves for the best places to pasture their charges. Their presence in the stable suggests that sinners are welcome in the Christ child's presence. Yet another thought suggests that these shepherds were tending the holy flocks of the temple at Jerusalem. The lambs from this flock were the sacrificial lambs, and these shepherds foretell the sacrifice Jesus would make 33 years later.

And there were in the same country shepherds abiding in the field, keeping watch over their flock by night. And, lo, the angel of the Lord came upon them, and the glory of the Lord shone round about them: and they were sore afraid. And the angel said unto them, Fear not: for, behold, I bring you good tidings of great joy, which shall be to all people. For unto you is born this day in the city of David a Savior, which is Christ the Lord. And this shall be a sign unto you; Ye shall find the babe wrapped in swaddling clothes, lying in a manger. And suddenly there was with the angel a multitude of the heavenly host praising God, and saying, Glory to God in the highest, and on earth peace, good will toward men. And it came to pass, as the angels were gone away from them into heaven, the shepherds said one to another, Let us now go even unto Bethlehem, and see this thing which is come to pass, which the Lord hath made known unto us.

**Luke 2:8–15** (King James Version)

## Materials

THE NUMBERS IN parentheses indicate the appliqué pieces as labeled on the pattern. In addition to the appliqué fabrics, you'll need the background fabric listed in "Materials for the Block Backgrounds" (page 22). Refer to "Making the Base" (page 19) and "Preparing the Background Blocks" (page 21) to prepare the background fabric.

Standing Shepherd
- 3" x 3" square of dark brown fabric for shoes (1 and 2)*
- 2" x 8" piece of brown wood-grain print for shepherd's crook (3)
- 3" x 8" piece of light brown print for robe (4 and 5)
- 3" x 7" piece of brown print for cloak and sleeve (6 and 8)
- 3" x 6" piece of tan fabric for face and hands (7 and 9) **
- 2" x 2" square of light brown print for headdress (10)
- 1" x 2" scrap of dark brown print for headband (11)

Kneeling Shepherd
- 1" x 4" piece of brown print for crook (1)
- 3" x 5" piece of light brown print for robe and sleeve (2 and 7)
- 3" x 5" piece of medium brown print for cloak (5)
- 2" x 2" square of olive green print for headdress (9)
- 1" x 2" scrap of dark brown print for headband (10)

Miscellaneous
- Black embroidery floss *or* black Pigma pen
- ¼ yard of lightweight fusible web (optional)

*You'll use this piece for the kneeling shepherd (3 and 4) also.*
**You'll use this piece for the kneeling shepherd (6 and 8) also.*

## Making the Block

PATTERNS FOR THE kneeling and standing shepherd appliqué pieces appear at right.

1. Refer to "Appliqué Techniques" (page 7) or use your preferred method to prepare the standing (1–11) and kneeling (1–10) shepherd appliqué pieces. Working in numerical order, position and appliqué the pieces to the background fabric to complete the figures as shown on the pattern.

2. Refer to "Embroidery Stitches" (page 12) and to the photo (page 27). Use the black embroidery floss to make small French knots for the eyes or mark them with a black Pigma pen.

### Modern-Day Shepherds and Their Flocks

If you want to learn more, you may be able to find a farmer with a flock of sheep and a trained sheepdog. Check local papers for fiber festivals—often held in the fall—that include sheepdog trials and demonstrations. A sheepdog managing a flock of sheep is something to behold. With simple commands, the farmer tells his dog how to move the sheep. One or two well-trained sheepdogs can move an entire flock of milling, grazing sheep.

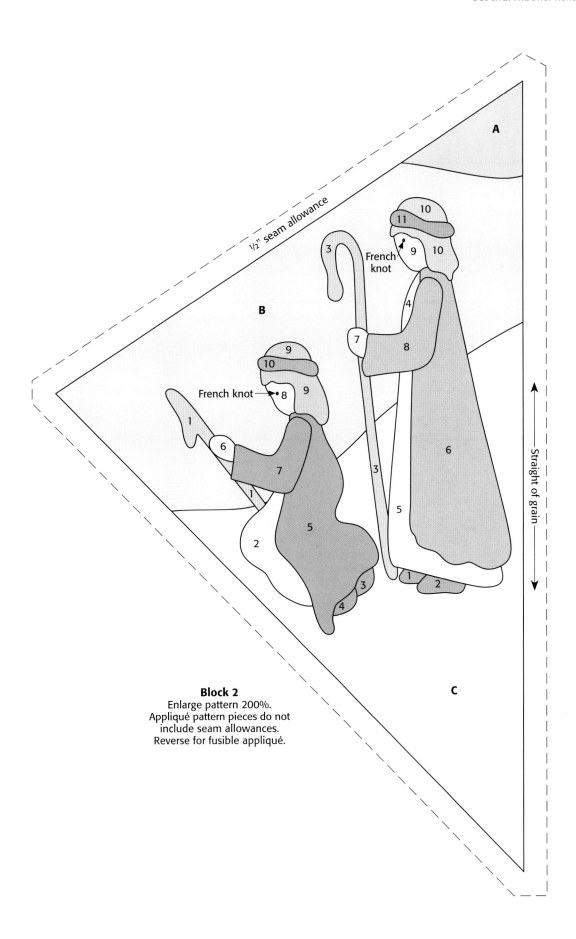

**Block 2**
Enlarge pattern 200%.
Appliqué pattern pieces do not
include seam allowances.
Reverse for fusible appliqué.

# BLOCK 3: THE SHEEP

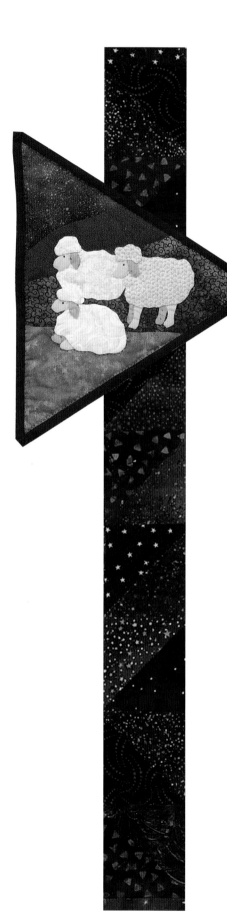

And then there are the sheep! Sheep are good followers, but not known for being very smart. They usually stay with their flock, but sometimes wander off and get themselves into trouble, falling into ravines and getting tangled up in briar bushes. Mother sheep are extremely loyal and want to care only for their own lambs. In the event that their baby dies, they must be tricked into helping out with orphaned lambs in their flock.

At the time of the Nativity, good pastureland—that is, land with a stream running through it—was rare. Most of the pastureland in the Middle East was on rocky hills. Sheep grazed on the scarce grasses and weeds growing among the rocks and between scrubby bushes. The flocks were moved from place to place, seeking out the best grazing area.

A legend tells us that long ago sheep had coarse, shaggy fur. On the night that Jesus was born, a lamb that lived in the stable sensed that the baby was cold, and snuggled next to him in the straw. The simple act of giving changed the lamb's shaggy coat into the soft wool that we know today.

## Materials

THE NUMBERS IN parentheses indicate the appliqué pieces as labeled on the pattern. In addition to the appliqué fabrics, you'll need the background fabric listed in "Materials for the Block Backgrounds" (page 22). Refer to "Making the Base" (page 19) and "Preparing the Background Blocks" (page 21) to prepare the background fabric.

- 4" x 4" square *each* of 3 different light gray prints for bodies and heads (1, 4, 9, 12, 15, and 18)
- 2" x 5" piece of light gray solid for faces and legs (2, 6, 8, 10, 14, and 16)
- 2" x 5" piece of medium-dark gray print for ears and legs (3, 5, 7, 11, 13, and 17)
- Black embroidery floss *or* black Pigma pen
- ¼ yard of lightweight fusible web (optional)

# Making the Block

Patterns for the sheep appliqué pieces appear below.

1. Refer to "Appliqué Techniques" (page 7) or use your preferred method to prepare the sheep (1–4, 5–12, and 13–18) appliqué pieces. Working in numerical order, position and appliqué the pieces to the background fabric to complete the figures as shown on the pattern.

2. Refer to "Embroidery Stitches" (page 12) and to the photo (page 30). Use the black embroidery floss to make small French knots for the eyes or mark them with a black Pigma pen.

**Block 3**
Enlarge pattern 200%.
Appliqué pattern pieces do not include seam allowances.
Reverse for fusible appliqué.

## Sharing Ourselves with Others

Max Lucado has written a story called *The Crippled Lamb* (see "Recommended Reading" on page 94), about a sheep that, because of a disability, has to stay behind while the rest of his flock is taken to the hills to graze. It's a story of loneliness and friendship; one that reminds us that who we are is important and that there are many ways of giving. Remember that one of the most important gifts we can give is the gift of ourselves—the gift of our time and presence in someone else's life.

# BLOCK 4:
# THE GOOD NEWS ANGEL

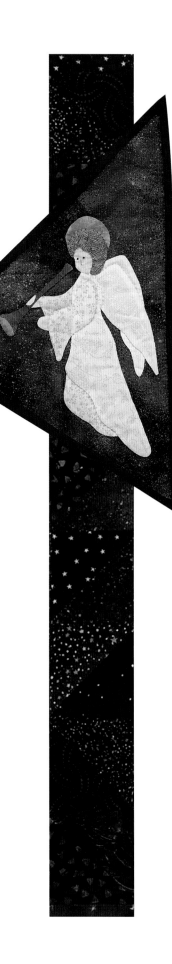

My husband, Dennis, is a minister, and our household bookshelves are graced with many translations of the Bible. I like to read how favorite passages are translated into more contemporary language, as in the New Revised Standard Version or the Peterson paraphrase in The Message (see "Recommended Reading" on page 94). But when I read the Christmas story, the little girl in me likes to go back to the King James Version of my childhood. That is the version I memorized as a child in the 1950s during summer vacation Bible school at the East Petersburg Church of the Brethren in Lancaster County, Pennsylvania. The passage that has stayed with me almost perfectly through the years is the Luke 2 narrative (page 27) of the events surrounding the birth of Jesus in Bethlehem.

The angel that comes to the shepherds doesn't have a name. But the message she has for the terrified shepherds is hopefully one to calm them down and bring them good news and instruction. When she has finished her message, she is joined by a heavenly chorus of angels who herald the news with a serenade of joyous music.

Angels most often appear as messengers or helpers. In this chapter of the Christmas story, the angel brings the scruffy, rowdy shepherds—and all people—good news of great joy. In a shabby stable, a baby is born whose only bed is the feeding trough meant for the animals sheltered there. His mother is a virgin, and his earthly father is a humble carpenter. The good news is that this baby is to be the savior for everyone. I am sure that as the shepherds headed to Bethlehem to verify the angel's news, they had no idea what it all meant. But because of an encounter with a host of God's angels, these men were compelled to find the stable and the baby.

## Materials

THE NUMBERS IN parentheses indicate the appliqué pieces as labeled on the pattern. In addition to the appliqué fabrics, you'll need the background fabric listed in "Materials for the Block Backgrounds" (page 22). Refer to "Making the Base" (page 19) and "Preparing the Background Blocks" (page 21) to prepare the background fabric.

- 3" x 3" square of gold print for halo (1)
- 4" x 6" piece of white fabric for wings (2, 3, and 4)
- 4" x 5" piece of beige print for inner robe and sleeves (5, 7, and 12)
- 2" x 3" piece of tan fabric for face and hands (6, 8, 10, and 15)
- 4" x 9" piece of very light beige print for outer robe (9)
- 3" x 3" square of light brown print for hair (11 and 11a)
- 2" x 5" piece of dark gold print for horn (13)
- 2" x 2" square of light gold print for inner horn (14)
- Tan embroidery floss
- Black embroidery floss *or* black Pigma pen
- ½ yard of lightweight fusible web (optional)

### Anticipation . . . and Appreciation

The holiday season is often one of eager anticipation and waiting for the wonder that is to come. The instant-gratification tone of our society makes waiting difficult, especially for children. Take some time, as Christmas approaches, to help children think about waiting and watching. Sit down with them and read a story about shepherds. *The Shepherd Boy's Christmas* by Bunshu Iguchi (see "Recommended Reading" on page 94) is one you may want to find. Talk about what it means to wait. This is also a good time to help children name the things that they have in their lives, both material and emotional. Help them make lists of favorite toys they have now and why the things on the list are so special. Help them remember when they received these things and who might have given them the gifts.

This is also a time for all of us to talk about nonmaterial, spiritual blessings: special people in our lives, places we have visited, experiences we treasure. Make treasure lists of both material and nonmaterial blessings. My own personal treasure list helps me focus on the season of blessings. Christmas is more than a time of presents and wishing for what we don't have. We know that. This can be a meaningful season for remembering the blessings that are part of every day we live.

## Making the Block

PATTERNS FOR THE good news angel appliqué pieces appear below.

1. Refer to "Appliqué Techniques" (page 7) or use your preferred method to prepare the angel appliqué pieces (1–15). Working in numerical order, position and appliqué the pieces to the background fabric to complete the figure as shown on the pattern.

2. Refer to "Embroidery Stitches" (page 12) and to the photo (page 32). Use the tan embroidery floss and an outline stitch to add the angel's nose. Use the black embroidery floss to make small French knots for the eyes or mark them with a black Pigma pen.

½" seam allowance

French knot

Outline stitch

Straight of grain

**Block 4**
Enlarge pattern 200%.
Appliqué pattern pieces do not
include seam allowances.
Reverse for fusible appliqué.

### Learn to Listen

Listen and be open each day for good news. Often we're more eager to listen to and pass on bad news. Think how great it would be if we listened more keenly for good news. As you work on this block, make it your mission to become more aware of positive things happening around you, and to share the good things you hear with a friend.

# BLOCKS 5 AND 6: THE STARS

The stars and the little town of Bethlehem just seem to go together when we talk about the Christmas story. We rarely tell the story without mentioning the star that guided Wise Men to the town where the Christ child was born.

Bethlehem, though small, was quite a town long before it became a part of the Christmas story. Bethlehem is just six miles south of Jerusalem. The name Bethlehem means house of bread, and the town stood in a fertile countryside. Bethlehem is where Jacob buried his beloved wife, Rachel, and where Ruth lived when she was married to Boaz. Even more, Bethlehem was the home and the city of David. It was from the ancestry of David that God was to send a savior. Micah 5:2 in the Old Testament tells us, "But you, O Bethlehem of Ephrathah, who are one of the little clans of Judah, from you shall come forth for me one who is to rule in Israel"(New Revised Standard Version).

The star that we read about in the Gospel of Matthew 2:1–3 was discovered and followed by astrologers at the time, whose job it was to watch the skies for special appearances. In ancient times, many people believed in the advice of astrologers—they believed that the future could be predicted and understood by studying the stars. Between 11 BC and 2 BC, several spectacular stellar events were recorded. We don't know exactly what brilliance the astrologers saw, but the account in the gospel of Matthew suggests that it was not a natural convergence of stars, but a unique, God-sent brilliance that guided the Magi to Jerusalem, and then moved on to Bethlehem and stood above the baby's home. It appeared

*suddenly and shone with particular brightness, and wise men of the time would most surely have given it royal significance. This was a time of great anticipation, and even the Roman historians were aware of the star's importance for the waiting world.*

*Most of us don't think much about the stars as we live day to day. I am fascinated by starry nights. During the summer of 1997, our family traveled to Arizona to visit my sister and her family. We drove three hours north of Phoenix into higher altitudes and cooler temperatures. We spent several very restful days at their little cottage tucked in a pine forest in the White Mountains. Far away from any lights and almost 8,000 feet high in the mountains, the stars seemed to drop out of the sky. Lying on my back, just gazing into the heavens, I could only imagine what the Magi might have felt when the natal star burst into the sky.*

## Materials (for Both Blocks)

THE NUMBERS IN parentheses indicate the appliqué pieces as labeled on the patterns. In addition to the appliqué fabrics, you'll need the background fabric listed in "Materials for the Block Backgrounds" (page 22). Refer to "Making the Base" (page 19) and "Preparing the Background Blocks" (page 21) to prepare the background fabric.

- 6" x 6" square *each* of 4 different medium to dark brown prints for houses (1–6 of block 5; 1–5 of block 6)
- ⅛ yard of gold print for stars (7–11 of block 5; 6 of block 6)
- ½ yard of lightweight fusible web (optional)

## Making the Blocks

PATTERNS FOR THE appliqué pieces appear on pages 37 and 38. I recommend that you work on one block at a time.

1. To make block 5, refer to "Appliqué Techniques" (page 7) or use your preferred method to prepare the village (1–6) and large star (7–11) appliqué pieces. Working in numerical order, position and appliqué the pieces to background block 5 as shown on the pattern.

2. To make block 6, repeat step 1 to prepare, position, and appliqué the village (1–5), and five star (6) appliqué pieces to background block 6 as shown on the pattern.

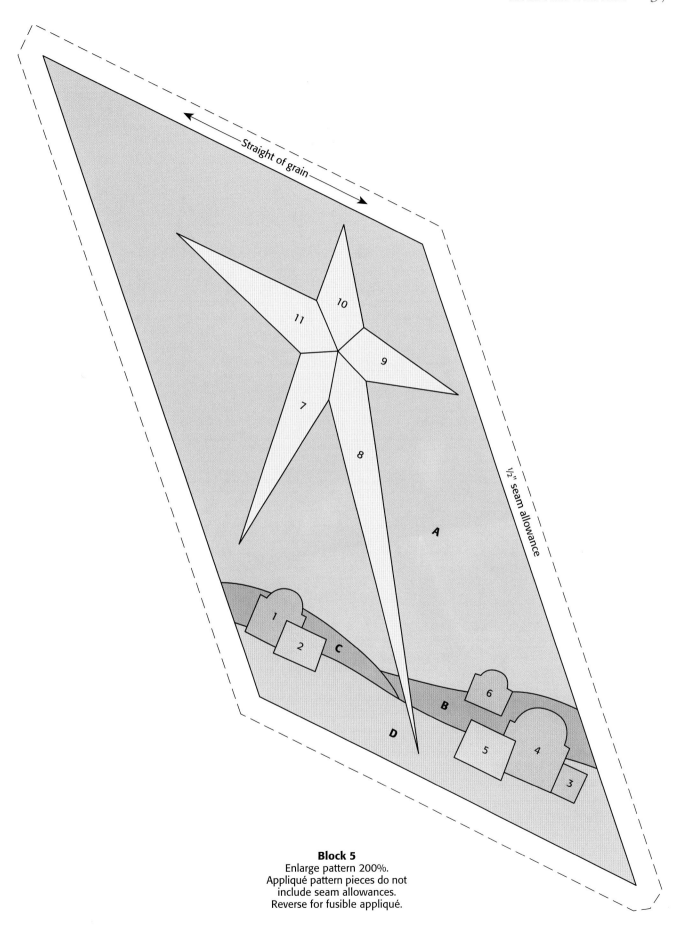

**Block 5**
Enlarge pattern 200%.
Appliqué pattern pieces do not
include seam allowances.
Reverse for fusible appliqué.

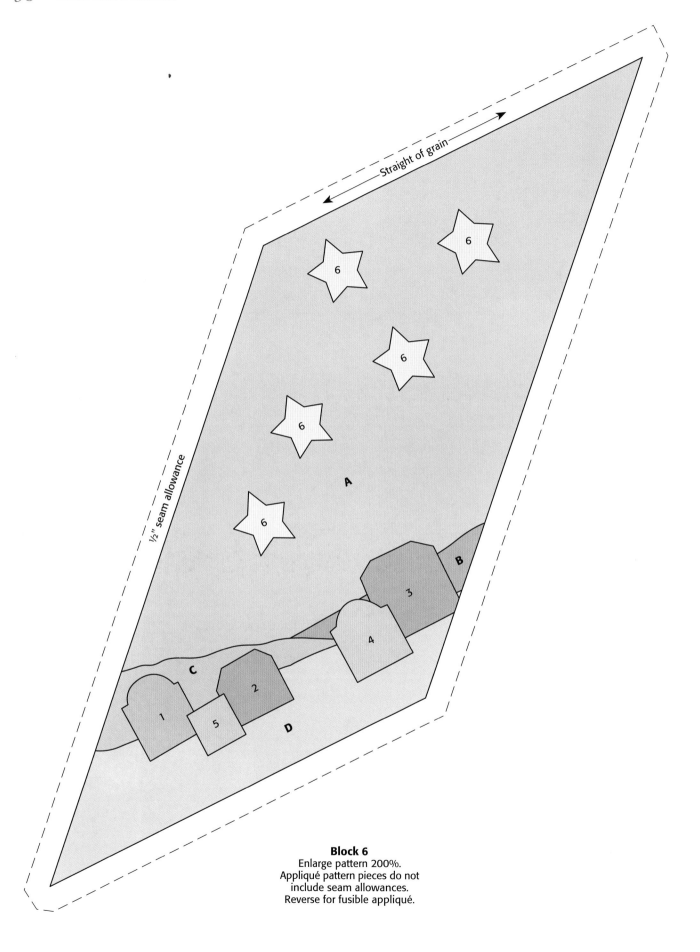

Straight of grain

½" seam allowance

A

B

C

D

1

2

3

4

5

6

6

6

6

6

**Block 6**
Enlarge pattern 200%.
Appliqué pattern pieces do not
include seam allowances.
Reverse for fusible appliqué.

# BLOCK 7:
# GASPAR OF THARSUS

The first of the Magi is Gaspar (some traditions call him Casper), the youngest of the Kings—clean-shaven and perhaps 20 years of age. He was said to be the king of Tharsus.

Gaspar's gift was frankincense. This was the gift offered by a priest, for the worship of the Most High in the Holy of Holies. The sweet and spicy fragrance of frankincense was the perfume of sacrifice and worship. The job of the priest was to open the way of communication with God. Through the prayers of the priest the common people could experience the presence of God. The gift of frankincense to Jesus suggests that the Wise Men understood his divinity.

## Materials

THE NUMBERS IN parentheses indicate the appliqué pieces as labeled on the pattern. In addition to the appliqué fabrics, you'll need the background fabric listed in "Materials for the Block Backgrounds" (page 22). Refer to "Making the Base" (page 19) and "Preparing the Background Blocks" (page 21) to prepare the background fabric.

- 6" x 6" square of maroon print for cloak and headband (1, 12, and 16)
- 2" x 4" piece of black fabric for box and shoes (2, 4, 18, 19, and 20)
- 7" x 9" piece of medium rose print for robe and sleeves (3, 5, 10, and 11)
- 2" x 2" square of brown fabric for staff (6 and 7)
- 1" x 1" square of gold print for staff end (8)
- 3" x 4" piece of deep rose print for headdress (14 and 15)
- 2" x 5" piece of striped fabric for ground cloth (17)
- 2" x 2" square of deep tan fabric for face and hand (9 and 13)
- Silver embroidery floss
- ¼ yard of lightweight fusible web (optional)

## Making the Block

PATTERNS FOR Gaspar, ground cloth, and box appliqué pieces appear at right.

1. Refer to "Appliqué Techniques" (page 7) or use your preferred method to prepare the Gaspar (1–16), ground cloth (17), and box (18–20) appliqué pieces. Working in numerical order, position and appliqué the pieces to the background fabric to complete the block as shown on the pattern.

2. Refer to "Embroidery Stitches" (page 12) and to the photo (page 39). Use the silver embroidery floss and a backstitch or outline stitch to embroider trim on Gaspar's cloak, his headband, and on the box.

### Learning from the Three Wise Men

In addition to the legend of Santa Claus, it is from the story of the Three Wise Men that we get the tradition of giving gifts at Christmas—and sadly, it's also from this tradition that we sometimes lose sight of the real meaning of Christmas. However, with some planning and foresight, we can make this part of Christmas as meaningful as all the rest.

Find a copy of the short story "The Gift of the Magi" by O. Henry (see "Recommended Reading" on page 94). Read it for yourself. If you have older children, read it to them and talk about what it means. If you have younger children, there is a wonderful book by Dorothea Lachner titled *The Gift from Saint Nicholas* (see "Recommended Reading"). It will help children think about the kinds of gifts we ask for, expect, and receive.

When my children were quite a bit younger, my husband and I began to feel that the number of gifts under the Christmas tree was getting out of hand, so we decided to follow the example of the Wise Men. For each of our children we selected three gifts. We set a budget for ourselves, and used their wish lists as a guide. They made their lists knowing that they would not get everything that appeared there. We based our choices on three categories: something they wanted, something they needed, and maybe the surprise of an unexpected treasure. There were still many gifts under the tree, but we felt we exercised some restraint by being selective and conscious about our gift giving.

I think that the frustration we sometimes feel around the holidays results from the discomfort we experience in wanting to celebrate the season, yet finding ourselves caught between the real meaning of the season and the pressures of a commercialized and materialistic world. It's difficult to find a happy medium, especially if you live with young children or with adults whose "toys" come with a high price tag. The challenge is to experience the delight of the season without becoming miserable and broke and exhausted.

Gaspar of Tharsus was a very young nobleman—perhaps even a king. Still he sought out the meaning of the star, and found himself traveling a great distance to find a child whose presence in the world would change history. We can do the same, taking time to find meaning in this season beyond what the advertisements would have us understand. We are never too young or too old to discover new challenges—new ways of doing things that will allow the season to have more meaning. Be open to seeing the star, whatever it may be, and to beginning the journey to a new place of understanding.

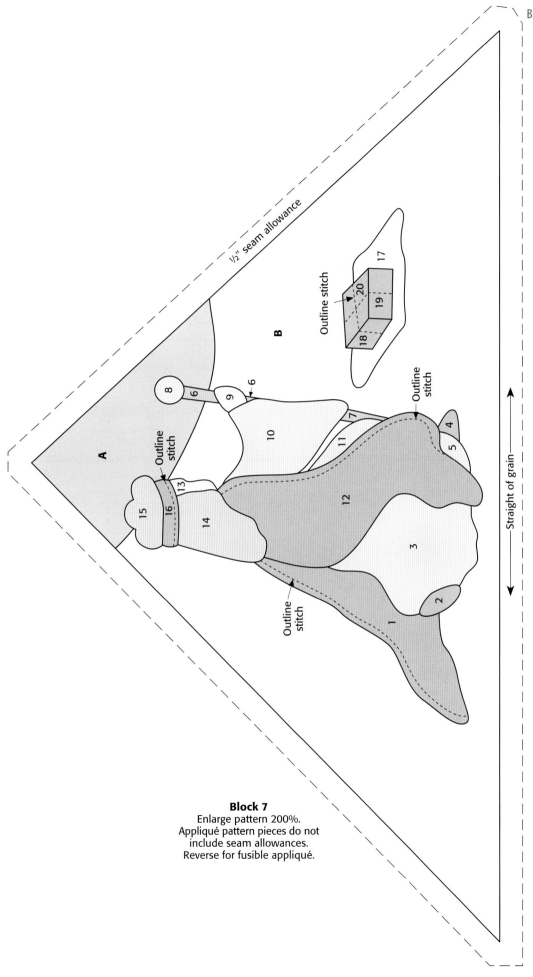

**Block 7**
Enlarge pattern 200%.
Appliqué pattern pieces do not
include seam allowances.
Reverse for fusible appliqué.

½" seam allowance

Straight of grain

Outline stitch

Outline stitch

Outline stitch

Outline stitch

A

B

# BLOCK 8:
# BALTHAZAR OF SABA

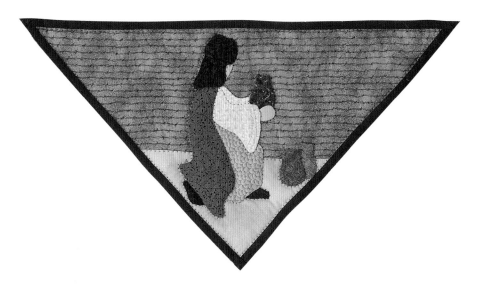

Legend has magnified and embellished the story of the Wise Men and the role they play in the Christmas story. The second Magi is Balthazar from Saba. Saba was a part of the Persian Empire and was later known as Sheba. Balthazar was older than Gaspar; he was probably a middle-aged man. He is often pictured as a dark-skinned king from Ethiopia, although that would make his home across the Red Sea from the Persian Empire, supporting the theory that he came from the African continent.

Balthazar brought the gift of myrrh, an aromatic resin from trees used to make perfume and incense. Myrrh, called the balm of Gilead, was also used in the process of embalming the dead, and myrrh is the gift to one who is to die. This seems a terrible gift to bring a new baby, and a very special child at that. However, if we look closely, we see that the Matthew passage (page 45) is not only a narrative, but a prophecy as well. Frankincense was the gift that foretold Jesus' role as a priest for all people, and myrrh speaks of his untimely death. Strange as the gift may seem, it should help us to stop and remember that this special birth and the visit of the Wise Men is more than an excuse to buy lots of gifts. There is a deeper meaning and a greater purpose for the birthday we celebrate at Christmastime.

## Materials

THE NUMBERS IN parentheses indicate the appliqué pieces as labeled on the pattern. In addition to the appliqué fabrics, you'll need the background fabric listed in "Materials for the Block Backgrounds" (page 22). Refer to "Making the Base" (page 19) and "Preparing the Background Blocks" (page 21) to prepare the background fabric.

- 3" x 4" piece of yellow print for sleeves (1 and 7)
- 3" x 3" square *each* of 3 different prints for pottery (2, 12, and 13)
- 1" x 2" piece of tan fabric for hand and face (3 and 9)
- 2" x 2" square of black fabric for shoes (4 and 5)
- 3" x 5" piece of gold print for robe (6)
- 3" x 7" piece of purple print for cloak (8)
- 3" x 3" square of dark purple print for headdress (10 and 11)
- Gold embroidery floss
- ¼ yard of lightweight fusible web (optional)

## Making the Block

PATTERNS FOR THE Balthazar and pottery appliqués appear on page 44.

1. Refer to "Appliqué Techniques" (page 7) or use your preferred method to prepare the Balthazar (1–11) and freestanding pottery (12 and 13) appliqué pieces. Working in numerical order, position and appliqué the pieces to the background fabric to complete the block as shown on the pattern.

2. Refer to "Embroidery Stitches" (page 12) and the photo (page 42). Use the gold embroidery floss and a backstitch or outline stitch to embroider trim on Balthazar's sleeve.

### The Magi

The story of the Magi is found in the Gospel of Matthew, and we are not told how many visitors there were. Much of the story that we know today has been developed over the years, tradition adding story onto story.

In the King James Version account of the birth of Jesus, the Magi are called Wise Men. More recent translations call them Magi or astrologers. Because there were three gifts offered to the Christ child, we have come to know them as the Three Wise Men. The biblical account of the visit is found in Matthew 2:1–11.

The early Christian church, fascinated by the mystery and apparent wealth and elegance of these men, gave much more attention to the Magi than to the lowly shepherds. Each of the Magi was given a name and age. Each was assigned one of the gifts and given a home country or kingdom.

It is not known how long it took the Magi to travel to Bethlehem. It's generally understood that they probably did not arrive on the same night as the birth or when the shepherds arrived. Most of us, however, have no trouble welcoming them to our manger scenes along with the shepherds, sheep, and angels. Some artists picture the baby Jesus sitting up in his mother's lap when the Wise Men come to honor him. In those pictures, the setting is a simple home and not the stable, and the child is older than a newborn infant.

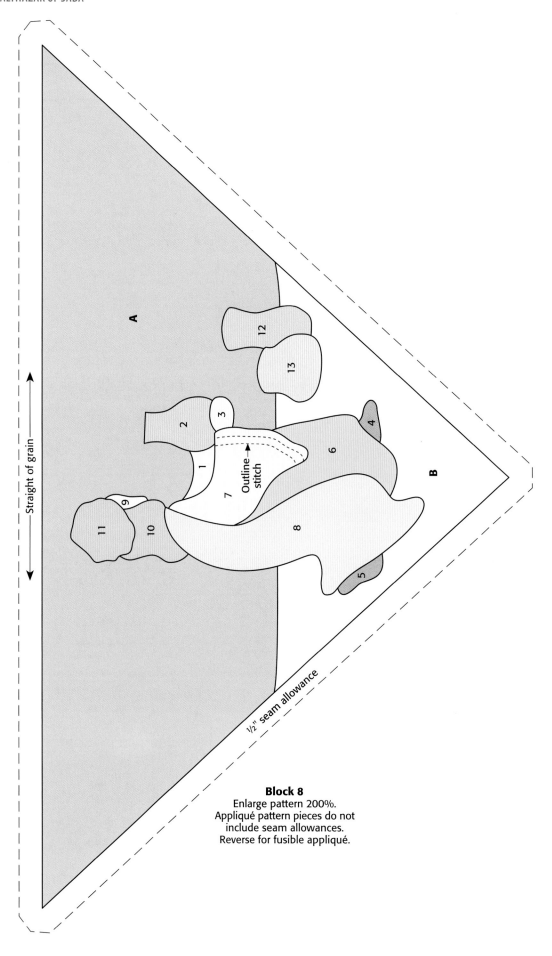

**Block 8**
Enlarge pattern 200%.
Appliqué pattern pieces do not
include seam allowances.
Reverse for fusible appliqué.

# BLOCK 9:
# MELCHIOR OF ARABIA

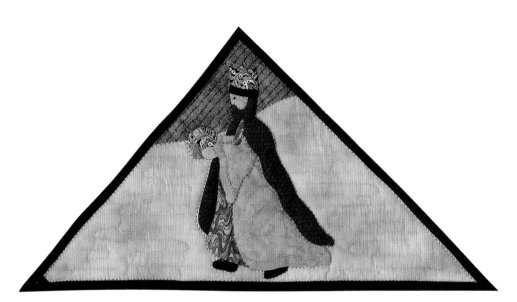

*I*t is Melchior who brings the gift of gold to the Christ child. Gold is the gift of kings, and for kings. This child was to be a king, but his reign and his kingdom were misunderstood. Our ideas of kings and kingdoms revolve around power and prestige and crowns and royal attire.

Melchior and his compatriots were indeed looking for a king, and bringing gold for the royal child. What they found was a baby, no longer in a stable, but in a very humble house. (They would have arrived some time after the birth, when the family had moved into more comfortable but simple surroundings.) As Joseph was not a man of wealth, the family's accommodations would no doubt have been quite simple. Nevertheless, the Magi, seeking a king, recognized this child as precisely the king they had been guided to by the star. For this reason, they bowed and worshipped him and presented him with regal gifts.

On coming to the house, they saw the child with his mother Mary, and they bowed down and worshipped him. Then they opened their treasures and presented him with gifts of gold and of incense and of myrrh.

**Matthew 2:11** (New International Version)

Melchior is the oldest of the Three Wise Men. He is usually shown bearded, and is definitely the elder statesman of this traveling group. If you

*had seen this group of scholars traveling with their servants and herdsmen, you would have known that Melchior was the senior member of the party, receiving the honor and respect of his fellow travelers simply by his manner.*

*I like to imagine that this caravan would have been a special group to travel with, even if I'd been a servant in charge of food or animals. Three men who set out to follow a star had to be pretty unusual. Being with them, listening to their stories and theories about the heavens and the reason this star led them from the comfort of their palaces, would have been fascinating. The Magi had a sense of how special the child was. I think their excitement would have made this journey special for everyone who took part.*

## Materials

THE NUMBERS IN parentheses indicate the appliqué pieces as labeled on the pattern. In addition to the appliqué fabrics, you'll need the background fabric listed in "Materials for the Block Backgrounds" (page 22). Refer to "Making the Base" (page 19) and "Preparing the Background Blocks" (page 21) to prepare the background fabric.

- 2" x 2" square of black fabric for shoes and crown band (1, 2, and 16)
- 2" x 4" piece of dark turquoise print for inner robe (3 and 8)
- 3" x 7" piece of red fabric for cloak (4, 6, and 12)
- 6" x 6" square of medium turquoise print for robe and sleeves (5, 7, and 11)
- 2" x 2" square of colorful print for chest (9)
- 2" x 2" square of deep tan fabric for hand and face (10 and 13)
- 2" x 2" square of brown print for beard (14)
- 2" x 2" square of gold print for crown (15)
- Silver embroidery floss
- Black embroidery floss *or* black Pigma pen
- ¼ yard of lightweight fusible web (optional)

## Making the Block

PATTERNS FOR THE Melchior appliqué pieces appear at right.

1. Refer to "Appliqué Techniques" (page 7) or use your preferred method to prepare the Melchior appliqué pieces (1–16). Working in numerical order, position and appliqué the pieces to the background fabric to complete the figure as shown on the pattern.

### Reserve Some Quiet Time

If you feel like you get a bit sidetracked during the holidays and wander from the manger, try to carve out a little quiet time each day for meditative reflection. You may think this is not a very good time to start finding time to be still. A good book might help you. For example, locate a copy of *Kneeling in Bethlehem* by Ann Weems, or *Faces at the Manger* by J. Barrie Shepherd (see "Recommended Reading" on page 94). If you take time, even occasionally, during your holiday preparations to sit and read one of the meditations or poems, you'll find yourself more aware of the blessings this season has to offer. The discipline of taking time for quiet is a present you can give yourself that will continue to give back to you peace of mind, a calm spirit, and joy in the tasks you must do as you prepare for Christmas Day. Reflection, meditation, journaling, and even resting are gifts that will continue to reap pleasant rewards and benefits for you in the year ahead.

2. Refer to "Embroidery Stitches" (page 12) and to the photo (page 45). Use the silver embroidery floss and a backstitch or outline stitch to embroider trim on Melchior's sleeve and hem. Use black embroidery floss to make a small French knot for the eye or mark it with a black Pigma pen.

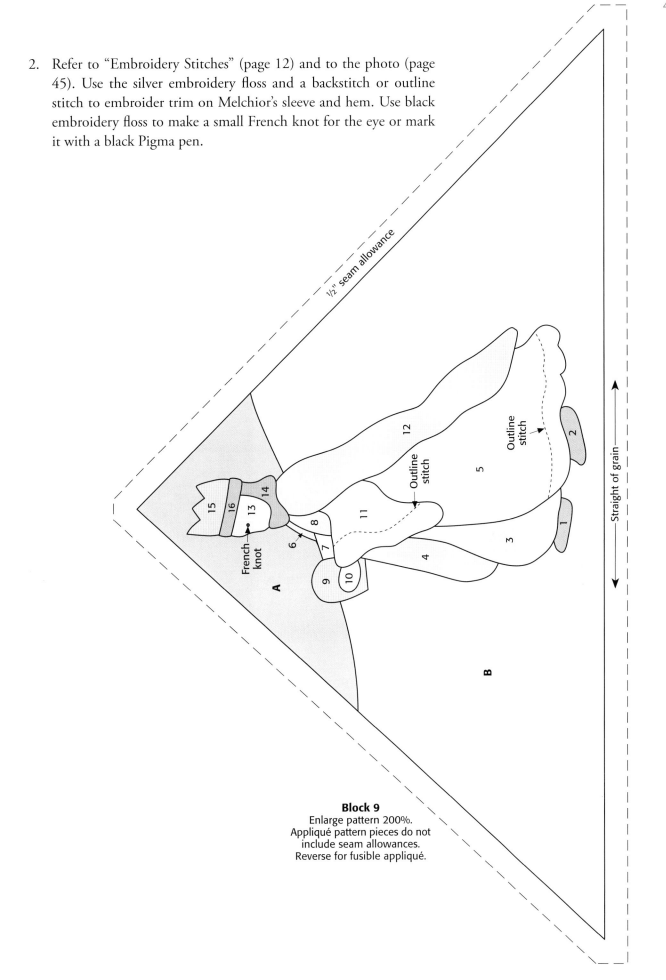

**Block 9**
Enlarge pattern 200%.
Appliqué pattern pieces do not include seam allowances.
Reverse for fusible appliqué.

# BLOCK 10: THE CAMELS

*T*he camels: homely, strong, ragged, and long suffering. The Matthew account of the birth of Jesus and the visit of the Wise Men does not mention them. However, in the prophetic writing of Isaiah, multitudes of camels are mentioned bringing gold and frankincense. So as with the Wise Men, we have added the rugged camels to the nativity scene. When we think about the Wise Men traveling from the East, the most logical beasts of burden to carry the gifts and supplies for the trip would have been camels.

Camels are known for conserving water and can go several days without drinking. Their humps are stores of fat that can be absorbed as nutrition when food is scarce. The dromedary is the camel with one hump; it is ridden with a saddle or used to carry loads of goods. More likely, however, the stockier, two-humped Bactrian camel would have been loaded with bundles and boxes and used for the Magi's journey. Bactrian camels can carry up to 1,000 pounds.

Camels can be a bit cantankerous. They are known to spit—not a great example for our children! Nevertheless, camels are charming in a humorous kind of way. There is a delightful story, titled The Last Straw *by Fredrick H. Thury (see "Recommended Reading" on page 94), about an old camel who is asked to carry some gifts to Bethlehem. By the time this old camel gets to Bethlehem, his bundles are piled high, and his joints are hurting, and his gout is painful. Read it to your children. Read it for yourself. The illustrations alone will make you smile.*

A multitude of camels shall cover you,
the young camels of Midian and Ephah;
all those from Sheba shall come.
They shall bring gold and frankincense
and shall proclaim the praise of the Lord.
**Isaiah 60:6** (New Revised Standard Version)

## Materials

THE NUMBERS IN parentheses indicate the appliqué pieces as labeled on the pattern. In addition to the appliqué fabrics, you'll need the background fabric listed in "Materials for the Block Backgrounds" (page 22). Refer to "Making the Base" (page 19) and "Preparing the Background Blocks" (page 21) to prepare the background fabric.

Standing Camel
- 6" x 6" square of dark brown print for legs and tail (1, 2, and 3)*
- 4" x 5" piece of brown fabric for body and legs (4 and 5)
- 3" x 4" piece of light brown print for head (6)
- 3" x 3" square of striped fabric for blanket (7)

Kneeling Camel
- 3" x 3" square of striped fabric for blanket (12)

Pottery and Ground Cloth
- 5" x 5" square of striped fabric for ground cloth (13)
- 3" x 3" square *each* of 4 or 5 different rust and beige fabrics for pottery (14–21)

Miscellaneous
- Black, tan, and dark brown embroidery floss
- Black Pigma pen (optional)
- ¼ yard of lightweight fusible interfacing

*You'll use this fabric for the kneeling camel's legs, body, and tail (8, 9, 10, and 11) also.*

## Making the Block

PATTERNS FOR THE kneeling and standing camel, ground cloth, and pottery appliqué pieces appear on page 5.

1. Refer to "Appliqué Techniques" (page 7) or use your preferred method to prepare the standing camel (1–7), kneeling camel (8–12), ground cloth (13), and pottery (14–21) appliqué pieces. Working in numerical order, position and appliqué the pieces to the background fabric to complete the figures, ground cloth, and pottery as shown on the pattern.

2. Refer to "Embroidery Stitches" (page 12) and to the photo (page 48). Use the black, tan, and dark brown embroidery floss and a backstitch or outline stitch to embroider the ear and leg details and reins on the camels. Use the black embroidery floss to make small French knots for the eyes or mark them with a black Pigma pen.

### The Importance of the Camel

Our American Christmas traditions don't make much of the camel except to include two or three in our nativity scenes. However, in other traditions, the camel is very important. In Spain, the Wise Men are very popular; they are the ones who bring presents to the children. On January 5, the Eve of Epiphany, Spanish children set out shoes filled with straw for the camels. In the morning, the straw is gone and there are presents left in its place.

In Syria, Epiphany is also the time the children receive their presents. But it's the smallest camel that brings the gifts. The story is told of the great caravan of camels that traveled with the Wise Men to find the Christ child. The smallest camel became tired to the point of exhaustion, but he wanted to see the baby so much that he would not give up. When Jesus saw how faithful the little animal was, he blessed the little camel with strength and immortality. So every year, it's this special little camel that comes bearing gifts for the good children of Syria. The lesson to be learned is that even the smallest and seemingly weakest among us has an important contribution to share.

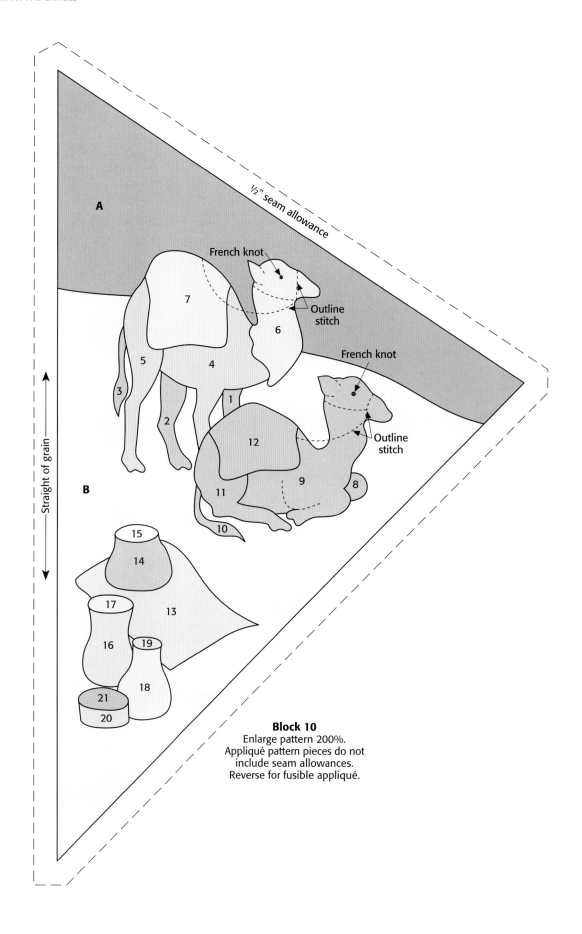

½" seam allowance

A

French knot

Outline
stitch

French knot

Outline
stitch

Straight of grain

B

7

6

5

4

3

1

2

12

9

8

11

10

15

14

17

13

16

19

21

18

20

**Block 10**
Enlarge pattern 200%.
Appliqué pattern pieces do not
include seam allowances.
Reverse for fusible appliqué.

# BLOCK 11:
# THE FRIENDLY BEASTS

From this brief statement in the gospel of Luke, we have come to believe that the infant Jesus was born in a stable. That is where we would find a manger—the feeding trough for the animals in the barn—filled with hay.

There is no mention of animals anywhere in the Christmas narrative, except for the sheep with their shepherds. Yet, over the years we have added a great variety of animals to the manger scene.

In the Old Testament, the prophet Isaiah tells of the time when "The wolf will live with the lamb, the leopard will lie down with the goat, the calf and the lion and the yearling together; and a little child will lead them"(Isaiah 11:6, New International Version).

The event in the stable was unusual; we imagine that any animals there would have been curious and uncharacteristically unafraid as they came close enough to see what was happening. They were not afraid of each other or of the humans in the stable.

There are many stories about the animals at Christmastime. One legend says that at midnight on Christmas Eve, the animals are given speech so they can tell the story of Christmas. Another legend tells of the spiders that spun their webs on fir trees, and when the baby saw the tiny threads, he touched them and turned them to threads of silver.

> And she brought forth her firstborn son, and wrapped him in swaddling clothes, and laid him in a manger.
>
> **Luke 2:7** (King James Version)

## Materials

THE NUMBERS IN parentheses indicate the appliqué pieces as labeled on the pattern. In addition to the appliqué fabrics, you'll need the background fabric listed in "Materials for the Block Backgrounds" (page 22). Refer to "Making the Base" (page 19) and "Preparing the Background Blocks" (page 21) to prepare the background fabric.

Cow
- 2" x 2" square of dark brown print for leg (1)
- 4" x 6" piece of brown print for body, ear, and head (2, 3, and 6)
- 2" x 2" square of light yellow print for horns (4 and 5)

Duck
- Small scrap of orange fabric for beak (7)
- 4" x 4" square of white fabric for body and wings (8 and 9)

Hen and Chicks
- Small scraps of orange and red fabrics for hen's beak (10) and comb (11)
- 3" x 3" square of light brown print for hen's body (12)
- 2" x 2" square of rust print for hen's wing (13)
- 3" x 3" square of yellow print for chicks (19, 20, and 21)

Pig
- 4" x 4" square of peach print for ear, legs, and body (14, 15, 16, 17, and 18)

Miscellaneous
- Dark brown, orange, and peach embroidery floss
- Black embroidery floss *or* black Pigma pen
- ¼ yard of lightweight fusible web (optional)

## Making the Block

PATTERNS FOR THE cow, duck, hen, chick, and pig appliqué pieces appear at right.

1. Refer to "Appliqué Techniques" (page 7) or use your preferred method to prepare the cow (1–6), duck (7–9), hen (10–13), pig (14–18), and three chick (19–21) appliqué pieces. Working in numerical order, position and appliqué the animals to the background fabric to complete the block as shown on the pattern.

2. Referring to "Embroidery Stitches" (page 12) and to the photo (page 51), use the dark brown embroidery floss and a backstitch or outline stitch to embroider the cow's ear and facial features, orange floss to embroider the hen's and chicks' feet, and peach floss to embroider the pig's snout, haunches, and tail. Use the black floss to make small French knots for the eyes or mark them with a black Pigma pen.

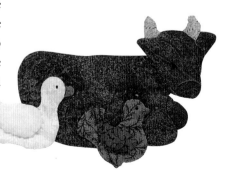

## The Friendly Beasts

As our children grew into their teenage years, Dennis and I began to feel as though our celebration of Christmas and gift giving was becoming much too self-centered. We searched for a way to bring some balance to our celebration. In addition to buying gifts for needy local children, we began a tradition of sharing a food-producing farm animal with families in need all over the word. It's a gift that keeps on giving.

Heifer International is based in Little Rock, Arkansas. Through this organization, you can "send" not only cows, but also sheep, goats, water buffalo, llamas, ducks, rabbits, and even hives of bees to needy families. Over the years, Dennis and I have given the gift of an animal in honor of our children, who receive a card and, if I can find one, an ornament that represents the animal we have given. Sometimes it is an animal figurine to add to our nativity scene. (Visit www.heifer.org on the Web for lots of information.)

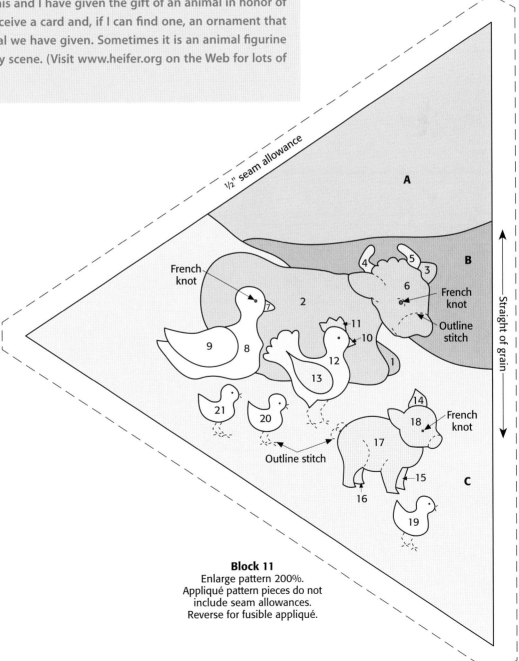

**Block 11**
Enlarge pattern 200%.
Appliqué pattern pieces do not include seam allowances.
Reverse for fusible appliqué.

# BLOCK 12:
# THE NATIVITY

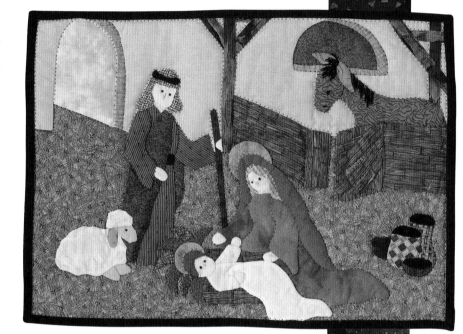

Finally we arrive at the stable, to see Mary and her baby, and faithful Joseph standing guard. At Christmas, this is what it's all about.

It is a faithful and very obedient Mary we see. Jewish tradition would tell us that she was probably quite young, possibly in her teens. Most Jewish girls were betrothed when they were 14 to 16 years old, so Mary's engagement to Joseph in her teen years was quite common. What was uncommon was her faith and her obedience to carry a child, knowing her pregnancy would be misunderstood in her religious community and knowing it would put her engagement to Joseph at risk. Both she and Joseph were surely the subject of much town gossip.

And then there was Joseph. He learned Mary was pregnant, and decided to quietly break the engagement without making a spectacle of the whole incident. After a visit from an angel, he reconsidered—a highly unusual decision. Again, faith and obedience make a difference.

As the end of Mary's pregnancy approached, the young couple found that they must make a trip to Bethlehem to be counted in the census. Since Joseph was a descendant of King David, he was required to return to Bethlehem, the town of his ancestors. The journey from Nazareth to Bethlehem was about 80 miles. When the couple finally reached the small town, it was crowded with many people arriving for the same reason. All the young couple could find for lodging was a stable—a simple shelter with straw and hay. It is here, in this most common place, that Mary gave birth to her first

child, a baby boy. I imagine the innkeeper's wife coming to the aid of the young couple and serving as a midwife for Mary.

As was the custom, Mary wrapped her child in swaddling clothes, which she probably brought with her, knowing that it was almost time for her to deliver. A swaddling cloth was a square piece of material with a long strip attached to one corner. One corner of the cloth was turned down, and the baby placed on the cloth with his head at the fold. The corners were folded in around him, ending with the corner with the long strip attached. The strip was wrapped around him tightly to hold him snugly in his blanket.

Bathed and wrapped in his blanket, this baby was cradled in a manger filled with straw—a logical place to put a baby if one's lodgings were a stable. Having delivered three babies of my own—in brightly lit, very sterile, and warm hospitals, with at least one doctor and several nurses in attendance—I can only imagine what the experience would be like in a dark, dusty stable, far from home and all that was familiar, bedded on straw, my husband or a midwife assisting the birth. When I think about the wonder of the Christmas story, I most often think about Mary. Not only was she asked to carry this child under very unusual circumstances, but she was not even home, near her mother or sisters who would have helped with the birth.

This was a very special family, settling in for the night in a stable many miles from home. They had each other, and as we know, they were not alone. The angels who announced the unusual pregnancy to Mary, and then to Joseph, surely were with them. And when the news of this humble birth was heralded to some lowly shepherds, the little family soon had quite a lot of company and attention.

God really knew these people.

In those days a decree went out from Emperor Augustus that all the world should be registered. This was the first registration and was taken while Quirinius was governor of Syria. All went to their own towns to be registered. Joseph also went from the town of Nazareth in Galilee to Judea, to the city of David called Bethlehem, because he was descended from the house and family of David. He went to be registered with Mary, to whom he was engaged and who was expecting a child. While they were there, the time came for her to deliver her child. And she gave birth to her firstborn son and wrapped him in bands of cloth, and laid him in a manger, because there was no place for them in the inn.

**Luke 2:1–7** (New Revised Standard Version)

God knew whom he was choosing. God knew they were strong enough and obedient enough to bring the mission of another way of living to the earth.

*God knew His message needed to come in human form. God knew it had to come from humble beginnings.*

*Luke 2:18–19 tells us, "All who heard it were amazed at what the shepherds said to them. But Mary treasured up all these things and pondered them in her heart" (New International Version). Mary knew. She knew that this conception and this birth would change the world. A mother knows. I also think there was a deep wonder in her soul, that she was the one chosen to be the earthly mother of the savior. When the shepherds came trooping into her stable nursery, telling their story of angels and messages, I'm sure she had much to wonder about and much to ponder.*

## Materials

THE NUMBERS IN parentheses indicate the appliqué pieces as labeled on the pattern. In addition to the appliqué fabrics, you'll need the background fabric listed in "Materials for the Block Backgrounds" (page 22). Refer to "Making the Base" (page 19) and "Preparing the Background Blocks" (page 21) to prepare the background fabric.

Unlike the other blocks, this block combines a multifabric background layered on muslin (pieces A and B, listed on page 22) *and* details (C–V, listed below) appliquéd using the same technique used for the figures.

### Stable
- 4" x 5" piece of light beige print for doorway (C)
- 4" x 6" piece of gold print for doorsill and windowsill (D, M, and N)
- Fat quarter of brown wood-grain print for rafters and fence (E–K and O–V)
- 4" x 6" piece of medium blue print for window (L)

### Donkey
- 4" x 6" piece of gray print for tail, body, mouth, and head (1, 2, 3, and 5)
- 3" x 3" square of light gray print for ears (4 and 6)

### Joseph
- 3" x 8" piece of medium brown print for cloak (1 and 10)
- 2" x 6" piece of tan fabric for hands and face (2, 8, 11, 13, and 18)*
- 4" x 7" piece of coordinating striped fabric for robe (3, 4, 5, 9, and 12)
- 1" x 2" piece of dark brown fabric for sash and headband (6 and 16)
- 2" x 3" piece of light-medium brown print for headdress (7, 14, and 15)
- 1" x 6" piece of wood-grain print for staff (17)

*\* You'll use this piece for Mary (3, 7, 8, and 20) and the child (13, 15, and 23) also.*

Sheep
- 3" x 3" square of light gray fabric for legs and face (1, 2, and 4)
- 3" x 5" piece of very light gray fabric for body and head (3 and 6)
- 3" x 3" square of dark gray print for ear (5)

Mary and the Child
- 2" x 3" piece of light gold fabric for halos (1 and 22)
- 6" x 8" piece of blue fabric for Mary's dress and sleeves (2, 5, 9, 11, and 21)
- 4" x 7" piece of dark blue fabric for Mary's veil (4)
- 2" x 3" piece of light brown or yellow print for Mary's hair (6 and 10)
- 3" x 4" piece of wood-grain print for manger (12 and 17)
- 2" x 3" piece of light blue fabric for the child's shirt and sleeve (14 and 16)
- 2" x 8" piece of gold print for straw (18)
- 3" x 6" piece of white or off-white tone-on-tone print for blanket (19)
- 2" x 2" square of light brown for the child's hair (24)

Pottery
- 4" x 4" square *each* of 3 or 4 different fabrics for baskets and jars (1–8)

Miscellaneous
- Black and tan embroidery floss
- Black Pigma pen (optional)
- 1 yard of lightweight fusible web (optional)

## Making the Block

PATTERNS FOR THE stable, donkey, Joseph, sheep, Mary, the child, and pottery appliqué pieces appear on page 59.

**Fig. 1**

1. Refer to "Appliqué Techniques" (page 7) or use your preferred method to prepare the doorway (C), doorsill and windowsill (D, M, and N), window (L), and rafters and fence (E–K and O–V) appliqué pieces. Working in alphabetical order *through piece P,* position and appliqué the pieces to the background block (fig. 1) as shown on the pattern. (Pieces Q–V will be appliquéd in step 3.)

2. Prepare the donkey (1–6) appliqué pieces. Working in numerical order, position and appliqué the pieces to the background block to complete the figure as shown. Refer to "Embroidery Stitches" (page 12) and to the photo (page 54). Use the black embroidery floss and a backstitch or outline stitch to embroider the facial features. Make a small French knot for the eye or mark it with a black Pigma pen. Use the black embroidery floss to make loopy fringe for the mane and stitch it in place.

3. Finish positioning and appliquéing the stable background (Q–V).

4.  Prepare and appliqué the pieces for Joseph (1–18). Use the tan embroidery floss to embroider the facial features. Use the black embroidery floss and make small French knots for the eyes or mark them with a Pigma pen.

5.  Prepare and appliqué the pieces for the sheep (1–6). Use the black embroidery floss to make a small French knot for the eye or mark it with a Pigma pen.

6.  Prepare and assemble the pieces for Mary (1–11, 20, and 21). Set them aside for now. You'll complete this figure in just a little while.

7.  Prepare and assemble the pieces for the child (12–17). Prepare seven straw pieces (six of piece 18 and one of piece 18 reversed) and the blanket (19). Prepare and assemble the remaining pieces of the child (22–24).

8.  Refer to the photo (page 54) and the pattern. Position and appliqué the units you prepared for Mary and the child, fitting them together so that Mary's veil (4) falls on the outside of her left sleeve (21) but under her dress (11), and her left hand (20) rests on the edge of the manger and the child's blanket (12 and 19).

9.  Refer to "Embroidery Stitches" (page 12) and to the photo (page 54). Use the tan embroidery floss to embroider Mary's and the child's facial features. Use black embroidery floss to make small French knots for the eyes or mark them with a Pigma pen.

10. Prepare and appliqué the pottery pieces (1–8).

### Recipe for Christmas Dinner

Take one family and place it around a table. Stir in some friends and neighbors. Ladle out steaming pots of love and laughter. Sprinkle with a fire flickering in the fireplace and a dash of candlelight. Serve generous portions of traditions both old and new. Add a variety of stories for all ages. Top with steaming cups of warm memories and continuing love. Garnish with hugs all around. Say a prayer of joy and thanksgiving. Have a blessed Christmas holiday.

### Remembering Christmases Past

Think back over the Christmases that have meant most to you, and I have a feeling those memories include some very special people. As you sit around your holiday table, include a dash of storytelling and pass on memories of wonderful or poignant times in your personal history. In my family, my husband and I used to say, "When I was young . . . " and then laugh because we had heard that phrase from *our* parents. But what followed that phrase was often a story that enlightened or entertained.

One of the great aspects of the Jewish holiday Hanukkah is the storytelling of the history of faith and family. Take time during the holidays to remember and to tell the stories of your heritage. Every once in a while, our children will say, "Remember the time we . . . " or, "Remember the Christmas when . . . " and I realize they have not forgotten the important details. Some years, we set out eight candles. As we light each one, we tell a favorite family story. This is an especially delightful tradition to develop with gatherings that include several generations.

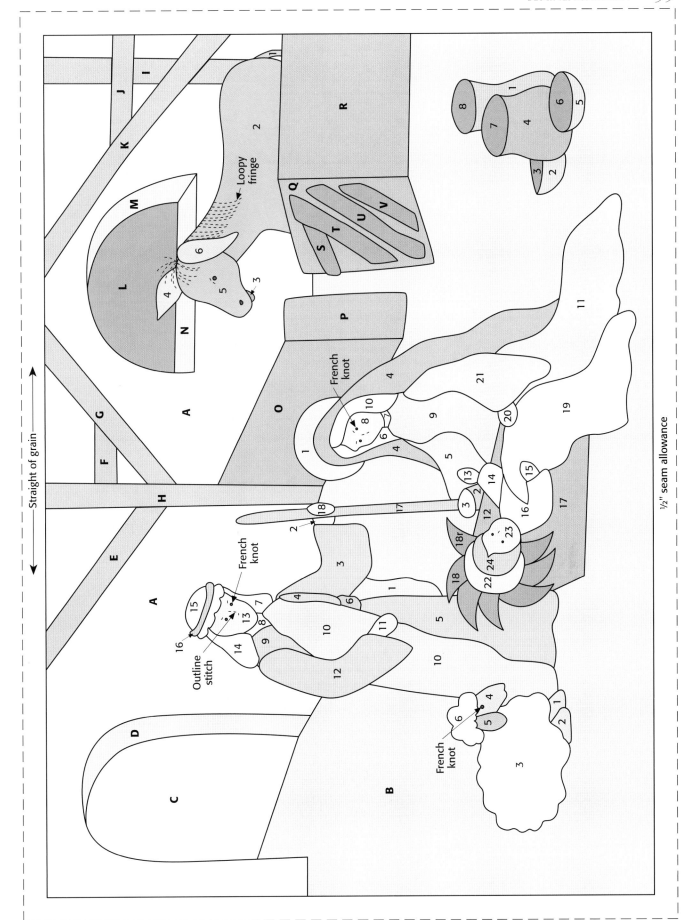

**Block 12**
Enlarge pattern 200%. Appliqué pattern pieces do not
include seam allowances. Reverse for fusible appliqué.

# BLOCK 13: JOSEPH'S ANGEL

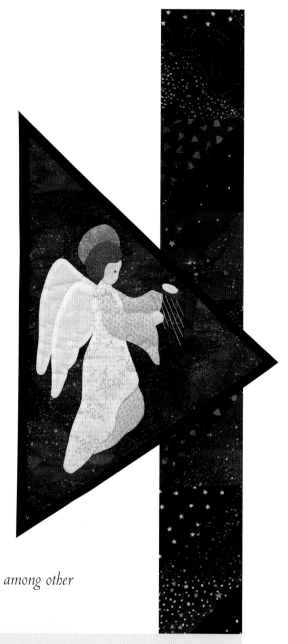

*H*ere is where the beauty and wonder of the Nativity story collide with reality. It is much easier to think of the shepherds returning to the hills to glorify God, and the Three Wise Men bowing to worship the child Jesus, than to imagine this little family slipping away in the middle of the night to avoid a jealous king who would kill the child.

Once again it is an angel who comes to Joseph in a dream to warn him of the danger facing his family, and it is Joseph's willingness to believe that leads him to pack his belongings and prepare his family for the journey to Egypt.

In the centuries before the birth of Jesus, the Jewish community was often persecuted and would find a safe haven in Egypt. Many cities in Egypt had colonies of Jews, so fleeing to Egypt in a time of crisis was probably a natural thing for this family to do. Joseph was doing what many of his ancestors had done in the face of disaster. The family would not be heading for the unknown. When they arrived, they would find a place among other Jewish families in the towns of Egypt.

When they [the Wise Men] had gone, an angel of the Lord appeared to Joseph in a dream. "Get up," he said, "take the child and his mother and escape to Egypt. Stay there until I tell you, for Herod is going to search for the child to kill him." So he got up, took the child and his mother during the night and left for Egypt, where he stayed until the death of Herod.

**Matthew 2:13–15** (New International Version)

## Materials

The numbers in parentheses indicate the appliqué pieces as labeled on the pattern. In addition to the appliqué fabrics, you'll need the background fabric listed in "Materials for the Block Backgrounds" (page 22). Refer to "Making the Base" (page 19) and "Preparing the Background Blocks" (page 21) to prepare the background fabric.

- 4" x 6" piece of white tone-on-tone print for wings (1 and 2)
- 4" x 7" piece of light-medium beige print for sleeves and inner robe (3, 4, and 8)
- 4" x 9" piece of light beige tone-on-tone print for outer robe (5)
- 2" x 2" square of tan fabric for hands and face (6, 9, and 10)
- 3" x 6" piece of dark brown print for harp (7)
- 2" x 3" piece of gold print for halo (11)
- 2" x 2" square of brown print for hair (12)
- Silver (or gold) embroidery floss
- Black embroidery floss *or* black Pigma pen
- ¼ yard of lightweight fusible web (optional)

## Making the Block

Patterns for the Joseph's angel appliqué pieces appear on page 62.

1. Refer to "Appliqué Techniques" (page 7) or use your preferred method to prepare the angel (1–12) appliqué pieces. Working in numerical order, position and appliqué the pieces to the background fabric to complete the figure as shown on the pattern.

2. Refer to "Embroidery Stitches" (page 12) and to the photo (page 60). Use the silver or gold embroidery floss and a backstitch or outline stitch to embroider the harp strings. Use the black embroidery floss to make small French knots for the eye or mark it with a black Pigma pen.

This is the last block you'll need to complete "The Adoration." Instructions for assembling the wall hanging follow on page 63.

### The Spider's Gift

There is a lovely legend told about the trip to Egypt. On their way, Mary and Joseph became weary and sought shelter in a cave. It was very cold, and there was frost on the floor and sides of the cave. A spider that lived there wanted to do something for the baby Jesus, so he spun a web over the entrance to the cave. As the night grew colder, the web was covered with a delicate frost that kept the cold from coming into the cave.

During the night, Herod's army came searching for the escaping family. They came to the cave and were about to charge in. But the captain saw the beautiful unbroken web and said to his soldiers, "This spider's web has not been broken. It is perfect. Surely no one could be in this cave." And they went on their way.

Some believe that we put tinsel on our Christmas trees to remind us of the protection of the spider's glittering web and that no gift is insignificant when given from the heart.

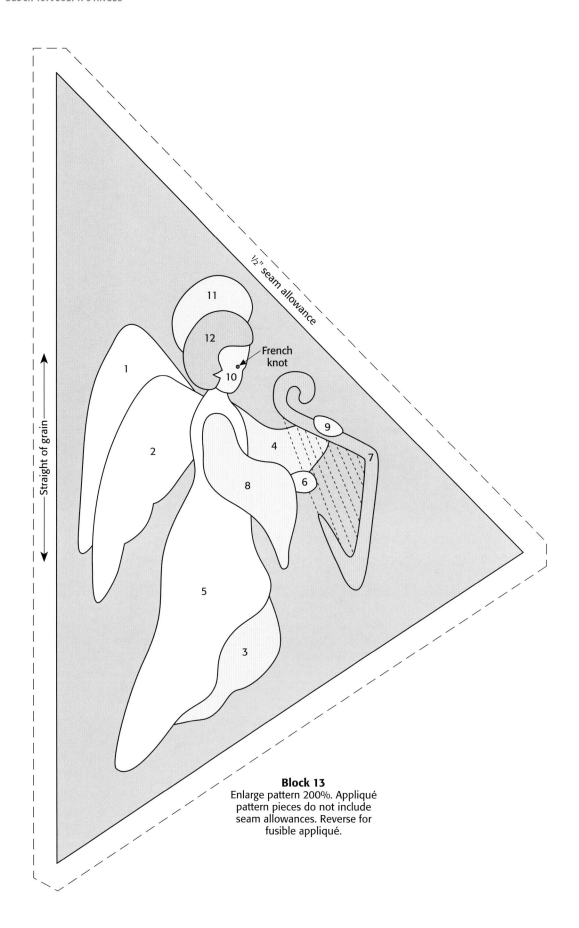

½" seam allowance

Straight of grain

11

12

French knot

10

1

9

2

4

7

8

6

5

3

**Block 13**
Enlarge pattern 200%. Appliqué
pattern pieces do not include
seam allowances. Reverse for
fusible appliqué.

# PIECING THE WALL HANGING

## Materials for Finishing

*All yardages are based on 40"-wide fabric.*
- 2¼ yards of dark print for outer border and binding
- ¼ yard of black solid for inner border
- 2⅞ yards of fabric for backing
- 52" x 48" piece of batting
- 7 yards of purchased ½"-wide black single-fold bias binding*
- Can of light basting spray

*\* If you prefer, use ½ yard of black fabric and ½" bias press bars to make your own bias tape.*

## Cutting

**From the *crosswise grain* (selvage to selvage) of the black solid, cut:**
- 4 strips, 1½" x 40"

**From the *lengthwise grain* of the dark print, cut:**
- 2 strips, 5" x 49"
- 2 strips, 5" x 54"

**From the remaining dark print, cut:**
- 2½"-wide bias strips to total approximately 200"

## Assembling the Wall Hanging

To ASSEMBLE THE wall hanging, you will need the tear-away base (pages 19–21), the freezer-paper templates you used to cut the block backgrounds, and the completed blocks (pages 22–62).

1. Trim the seam allowance on each freezer-paper template from ½" to ¼" on all sides.

2. Carefully press each finished block. Using a dry iron, press the appropriate trimmed template, waxy side down, onto the right side of the matching block. Trim the blocks even with the template.

3. Place each block in its designated position on the tear-away base so the *finished* edges of the block rest on the lines drawn on the base; spray baste in place. The edges of the blocks should overlap, with each extending ¼" on each side of the line. Hand baste through all layers to secure.

### Choosing Border Fabric

Unless some of the appliquéd pieces overlap the borders, I like to wait until the quilt top is finished before I choose the border fabrics. So often I buy something I think will work, and then change my mind completely when I see the finished top.

4. Beginning with the spokes (angled lines), cover the raw overlapping edges with ½"-wide bias binding. Secure with a hand or machine blind stitch (fig. 1).

5. Beginning at one corner, repeat step 4 to cover the raw edges of the center block (block 12). Miter the corners and hide the tail end of the bias binding in the last miter (fig. 2).

## Adding the Borders

1. Refer to "Squared Borders" (page 12) as needed to join, measure, trim, pin, and sew the 1½"-wide black inner-border strips to the sides, top, and bottom of the quilt.

2. Refer to "Mitered Borders" (page 13) as needed to measure, trim, pin, and sew the 5" x 49" dark print outer-border strips to the sides and the 5" x 54" dark print outer-border strips to the top and bottom of the quilt. Miter the corners.

3. Carefully remove the tear-away base.

## Finishing

REFER TO "Finishing Your Quilt" (page 14) as needed to complete these finishing steps for your quilt.

1. Layer the backing, batting, and top; baste.

2. Quilt as you prefer.

3. Use the 2½"-wide dark print bias strips to bind the edges of the quilt.

4. Be sure to add a label!

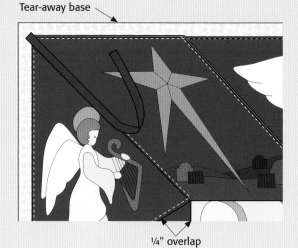

Tear-away base

¼" overlap

**Fig. 1**

**Fig. 2**

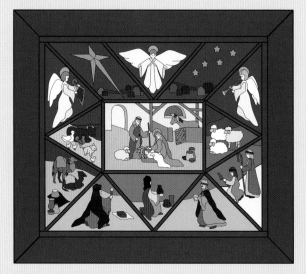

Quilt plan

# Do Not Be Afraid

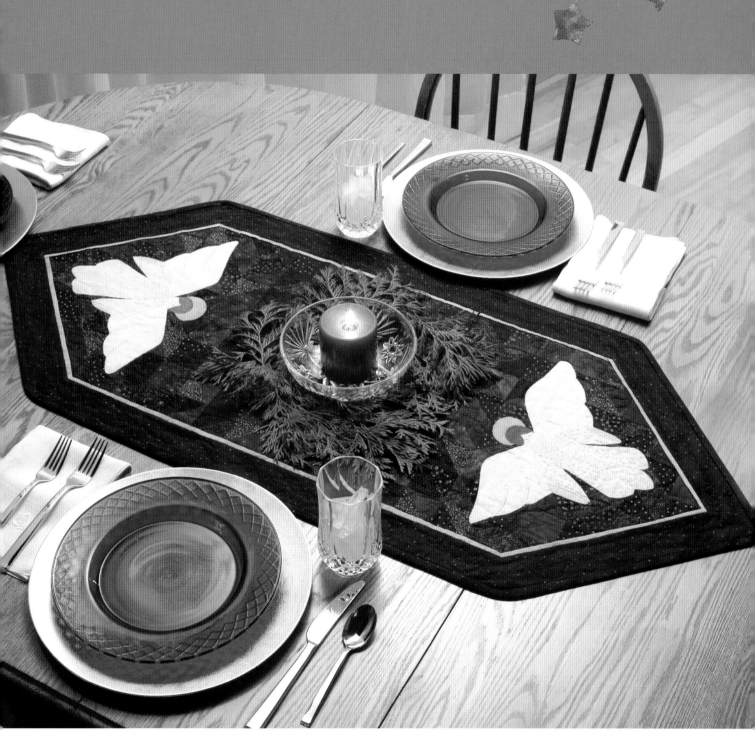

*Pieced and appliquéd by Rachel W. N. Brown,
21" x 49". Quilted by Cece Altomonte.*

*A*s the season of Advent and Christmas approaches, we have a chance to reflect on past holidays—what was most meaningful, and what we would like to do differently this holiday season. Gabriel brings a message to "fear not."

When you finish this table runner, place it on the dining-room table. Light one candle. Sit down with a cup of tea and handwrite a note of encouragement to someone. If you have young children or grandchildren, help them write a note of love or thanks to a friend or relative. Keep it simple—perhaps a picture drawn and colored by little ones. Help them learn to reach out at this time of the year, and remind yourself to do the same.

## Materials

*All yardages are based on 40"-wide fabric. Appliqué fabric includes enough to make both angels. If you prefer to make the angels from different fabrics, you'll need half as much of each.*

- 1⅔ yards of medium-dark blue print for outer border and binding
- 1 yard *total* of assorted medium-dark blue tone-on-tone, star, and marbled prints for pieced background*
- ¼ yard of gold tone-on-tone print for flat piping (inner border) and halo appliqués (3)
- ⅛ yard of white tone-on-tone print for wing appliqués (1 and 2)
- ⅛ yard of beige tone-on-tone print for robe appliqués (4, 5, 6, and 11)
- 6" x 6" square of beige print for sleeve lining and sash appliqués (7, 8, 12, and 13)
- 2" x 5" piece of tan fabric for hand and face appliqués (9, 10, and 14)
- 2" x 4" piece of brown print for hair (15)
- 1½ yards of fabric for backing
- 25" x 52" piece of thin cotton batting
- 1 yard of lightweight fusible web (optional)
- White embroidery floss
- Black embroidery floss *or* black Pigma pen

*\*If you work with scraps, the pieces must be at least 3" x 3" (or 3"-wide strips). You may use some of the leftovers from the border and binding fabric for the pieced background if you wish. If you choose to do so, cut the border and binding strips first.*

## Think Ahead for Binding

Here's a timesaving, anxiety-reducing tip I learned from my friend and teacher Dianne Louvet. Cut, sew, fold, and press your binding when you're cutting the borders for your project. Set the cut binding aside and it will be ready as soon as the piece is quilted. You'll have that little job finished, and you'll not cut into your binding fabric by mistake, or stash it and forget where you put it.

## Cutting

*Cut all strips across the width of the fabric (selvage to selvage) unless instructed otherwise.*

**From the assorted blue tone-on-tone, star, and marbled prints, cut** *a total of:*
- 128 squares, 2⅞" x 2⅞"
- 4 squares, 4" x 4"; cut each square twice diagonally to yield 4 quarter-square setting triangles (16 total)

**From the gold tone-on-tone print, cut:**
- 2 strips, 1" x 30"
- 4 strips, 1" x 15"

**From the** *lengthwise grain* **of the medium-dark blue print, cut:**
- 2 strips, 2¾" x 32"
- 4 strips, 2¾" x 20"

**From the remaining medium-dark blue print, cut:**
- 2½"-wide bias strips to total 160"

## Piecing the Background

You can make half-square-triangle units by following the steps below, or you may want to try using triangle papers instead. I've also used the Angler 2 tool to eliminate the need for marking the diagonal lines and to speed the stitching process. See "Resources" on page 95 for additional information.

1. Draw a diagonal line on the wrong side of 64 of the 2⅞" blue print squares. Place a marked square right sides together with a randomly selected, unmarked 2⅞" square and stitch ¼" from both sides of the drawn line as shown. Cut on the marked line to create two half-square-triangle units. Press the seam allowance to one side. Make 128 half-square-triangle units (fig. 1).

2. Sew eight units from step 1 together to make a row, taking care to orient the units as shown; press. Make 13 rows total, orienting the units in each row as shown. Press the seams in opposite directions from row to row. Sew the rows together to make a unit that measures 16½" x 26½"; press (fig. 2).

3. Sew six remaining units from step 1 and two blue print quarter-square triangles together as shown; press (fig. 3). Make two.

4. Sew four remaining units from step 1 and two blue print triangles together as shown; press (fig. 4). Make two. Repeat using two units from step 1 and two blue print triangles (fig. 5). Make two.

Make 128.

**Fig. 1**

**Fig. 2**

Make 2.

**Fig. 3**

Make 2.

**Fig. 4**

Make 2.

**Fig. 5**

5. Sew two blue print triangles together as shown; press (fig. 6). Make two.

6. Arrange and sew one unit from step 3, one of each unit from step 4, and one unit from step 5 together as shown; press (fig. 7). Make two.

7. Sew one unit from step 6 to each short end of the unit from step 2; press (fig. 8).

Make 2.

**Fig. 6**

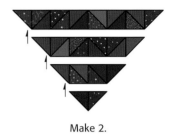

Make 2.

**Fig. 7**

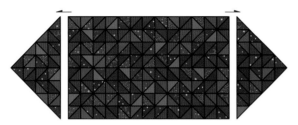

**Fig. 8**

## Adding the Appliqués

I used the fusible method to appliqué the angels to the background unit. Refer to "Appliqué Techniques" (page 7) for guidance as needed. Patterns for the appliqué pieces appear on page 26.

1. Use your preferred method to prepare two sets of angel (1–15) appliqué pieces. Refer to the photo (page 65) and the diagram below. Working in numerical order, position and appliqué the pieces for one angel to each end of the pieced table runner as shown on the pattern.

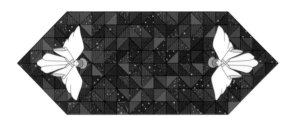

Appliqué placement diagram

2. Refer to "Embroidery Stitches" (page 12) and to the photo (page 65). Use the white embroidery floss and a backstitch or outline stitch to add detail to the wings. Use the black embroidery floss to make small French knots for the eyes or mark them in place with a black Pigma pen.

## Adding the Borders

REFER TO "Adding Borders" (page 12) as needed.

1. Press each 1"-wide gold strip in half lengthwise, wrong sides together, to make folded-piping strips.

2. With right sides together, align the raw edges of a folded 1" x 30" piping strip even with the raw edge of one long side of the table runner. Allow for equal overhang on each end. Stitch, using a ⅛"-wide seam. Trim using the angle of the triangle edge as a guide as shown. Do not press. Repeat to add a folded-piping strip to the opposite side of the table runner (fig. 9).

3. Repeat step 2 to sew two 1" x 15" folded-piping strips to each end of the table runner. Trim as shown and press (fig. 10).

4. With right sides together, and the folded-piping strips sandwiched between, center and stitch a 2¾" x 32" medium-dark blue border strip to each long side of the table runner. Allow for equal overhang on each end. Press the seams toward the newly added border, and trim using the angle of the triangle edge as a guide (fig. 11).

5. Repeat step 4 to sew two 2¾" x 20" medium-dark blue strips to each end of the table runner. Referring to "Mitered Borders" (page 13), miter and trim the end points as shown; press (fig. 12).

## Finishing

REFER TO "Finishing Your Quilt" (page 14) as needed to complete your table runner.

1. Layer the backing, batting, and top; baste.

2. Quilt as you prefer.

3. Trim the batting and backing close to the edge of the table runner top and use the 2½"-wide bias strips to bind. Round the corners slightly and miter the binding at the points.

4. Be sure to add a label!

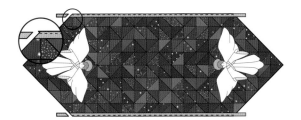

**Fig. 9**

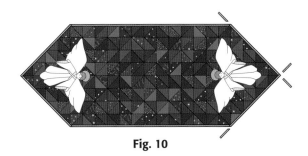

**Fig. 10**

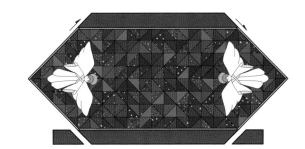

**Fig. 11**

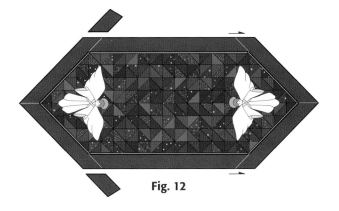

**Fig. 12**

# The First Gift of Christmas

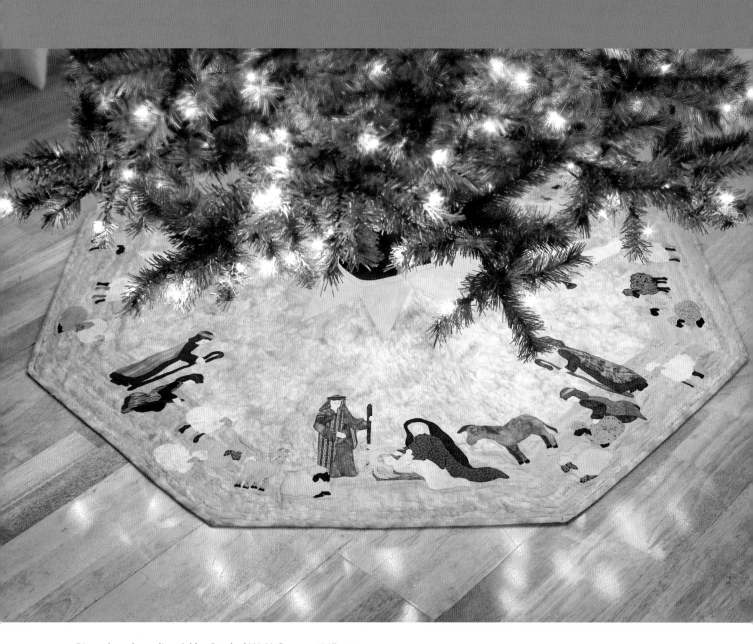

*Pieced and appliquéd by Rachel W. N. Brown, 54" octagon
(approximately 21" per side). Quilted by Brown Bird Quilts.*

I n our home, the celebration of Christmas doesn't end on December 26. Often the hectic pace of the season finds us wishing we had more time. There are always friends we would have liked to entertain, but we simply ran out of time. So we extend our season. The tree, adorned with this tree skirt, stays up if it's not dropping its needles. We keep the dining-room table stretched out with all its leaves, Christmas carols playing on the CD player, and invite friends in for dinners or for evenings of board games and dessert. Usually our guests contribute part of the meal so no one has to do all the work. These are often the best of times, remembered long after the holiday has passed.

## Materials

*All yardages are based on 40"-wide fabric. Fabric requirements for the standing and kneeling shepherd appliqué pieces appear on page 28; the good news angel on page 33; Joseph, Mary, and the child on pages 56–57; and Joseph's angel on page 61. You will need enough fabric for two kneeling shepherds (one regular and one reversed) and four standing shepherds (two regular and two reversed).*

- 1½ yards of light gold-and-green batik stripe for border (base) units and binding
- 1½ yards of light blue print for sky (tall trapezoid) units and binding
- ½ yard of gold fabric for center star and binding
- ½ yard *total* of assorted light and medium gray fabrics for sheep body (9 and 15), sheep head (12 and 18), goat (1–16), and donkey (1–13) appliqués
- ¼ yard *total* of assorted dark gray and black fabrics for sheep face (10 and 16), ear (11 and 17), and feet (5–8, 13, and 14) appliqués
- Scrap of yellow fabric for goat horn appliqués (17 and 18)
- 3⅓ yards of fabric for backing
- 56" x 56" piece of batting
- ⅜ yard of nonwoven fusible interfacing designed for sheer fabric
- 2 yards of lightweight fusible web (optional)
- Nonstick pressing sheet
- Freezer paper
- 24"-long ruler and pencil
- Silver or gold embroidery floss
- Black embroidery floss *or* black Pigma pen

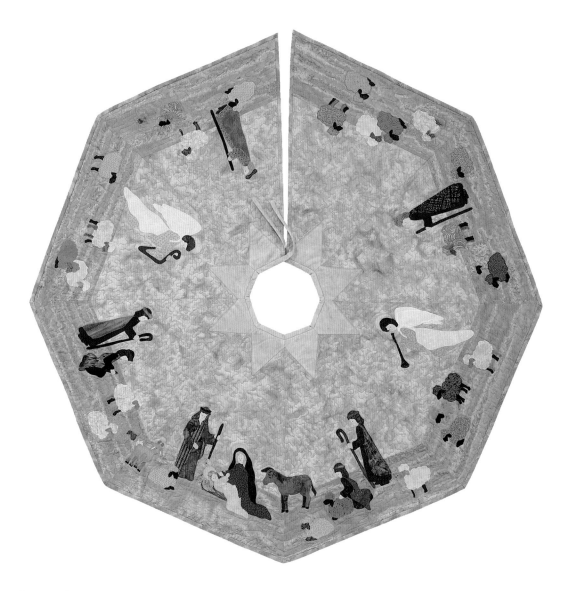

## Cutting the Tree Skirt Pieces

THE TREE SKIRT is made in eight sections. Each section is pieced in three units: the border (base) unit, the sky (tall trapezoid), and a star point that is appliquéd in place. To make the templates, you'll need freezer paper, a 24" ruler, and a pencil.

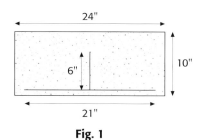

**Fig. 1**

### The Border (Base) Units

1. Draw a 21" horizontal line near the bottom edge of a 10" x 24" piece of freezer paper. Find and mark the midpoint of this line (10½").

2. Draw a 6" line perpendicular to the line you drew in step 1 upward from the midpoint as shown (fig. 1).

3. Carefully place the 8" mark of your ruler on the top point of the 6" line you drew in step 2. Draw a line 16" long and parallel to the bottom line as shown (fig. 2).

**Fig. 2**

4. Connect the right ends of the top and bottom lines as shown. Repeat with the left ends. Add a ¼"-wide seam allowance to all sides of the shape. Mark the grain line as shown (fig. 3). Cut out the freezer-paper border (base) template on the outermost line.

5. Use the template to cut eight border (base) pieces from the gold-and-green batik.

**Fig. 3**

### The Sky (Tall Trapezoid) Units

1. Draw a 16" horizontal line near the bottom edge of a 20" x 20" piece of freezer paper. Find and mark the midpoint of this line (8").

2. Draw a 15¾" line perpendicular to the line you drew in step 1 upward from the midpoint as shown (fig. 4).

3. Carefully place the 1½" mark of your ruler on the top point of the 15¾" line you drew in step 2. Draw a line 3" long and parallel to the bottom line as shown (fig. 5).

4. Connect the right ends of the top and bottom lines as shown. Repeat with the left ends. Add a ¼"-wide seam allowance to all sides of the shape. Mark the grain line as shown (fig. 6). Cut out the freezer-paper sky (tall trapezoid) template on the outermost line.

5. Use the template to cut eight sky (tall trapezoid) units from the blue print.

**Fig. 4**

**Fig. 5**

### The Star Points

1. Use the pattern (page 75) to make a template for the star point. Use the template to cut eight star points *each* from both the gold fabric and the nonwoven fusible interfacing.

2. Place the fusible side of a cut piece of interfacing on the right side of a cut gold fabric piece. Stitch ¼" from the raw edge on the two long sides as shown on the pattern. Trim the point, turn the unit, and press on a pressing sheet. The fusible side will now be on the outside. Make eight.

**Fig. 6**

## Assembling the Units

1. With right sides together, sew each border piece to a sky piece as shown at right; press. Sew with the border piece on top. The feed dogs of your sewing machine will help ease in any excess fabric and keep the units from stretching.

2. Following the manufacturer's directions, iron a faced star point to the top of each unit from step 1. Use a blanket stitch or blind hem stitch and matching thread to secure the edges (fig. 7). Make eight.

Make 8.

**Fig. 7**

## Adding the Appliqués

REFER TO "Appliqué Techniques" (page 7) for guidance as needed. Patterns for the kneeling and standing shepherd appliqué pieces appear on page 29; the sheep on page 93; the good news angel on page 34; Joseph, Mary, and the child on page 59; Joseph's angel on page 62; the donkey on page 93; and the goat on page 93.

1.  Use your preferred method to prepare the appliqué pieces for 2 kneeling shepherds (1 regular, 1 reversed); 4 standing shepherds (2 regular, 2 reversed); 9 standing sheep (5 regular, 4 reversed); 19 kneeling sheep (11 regular, 8 reversed); the good news angel; Joseph; Mary and the child; Joseph's angel; 1 donkey; and 1 goat reversed.

2.  Set the prepared donkey and goat appliqués aside for now. Refer to the tree skirt photo (page 72) to position and appliqué the remaining figures to the appropriate sections.

3.  Referring to "Embroidery Stitches" (page 12), use the silver or gold embroidery floss to add the angel's harp strings. Use the black embroidery floss to make small French knots for the eyes and embroider the human and animal facial features, or mark the eyes and features with a black Pigma pen.

## Assembling the Tree Skirt

1.  With right sides together and long raw edges aligned, begin sewing the sections together in pairs in the order shown in the photo (page 72). Press the seams open. Make four pairs. Sew two pairs together to make a half; press. Make two. Sew the halves together, leaving the seam between the first and last unit unsewn; press.

2.  Position and appliqué the donkey and goat over the appropriate seams as shown in the photo. Use the black embroidery floss to make small French knots for the eyes or mark them with a black Pigma pen.

## Finishing

REFER TO "Finishing Your Quilt" (page 14) as needed to complete these finishing steps for your tree skirt.

1.  Layer the backing, batting, and top; baste.

2.  Quilt as you prefer.

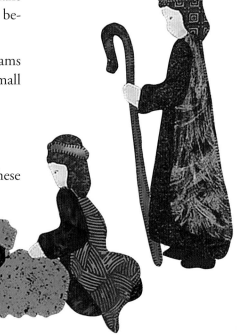

3.  Trim the batting and backing close to the edges of the tree skirt and use the remaining blue print to make 2½"-wide bias strips to total 40". Use the remaining gold-and-green batik to make 2½"-wide bias strips to total 200". Use these bias strips to bind the two side edges and the outside edges of the tree skirt, changing the color of the binding to match the color of the skirt. Round the corners slightly and miter the binding at the points.

4.  Use the remaining gold fabric to make 2½"-wide bias strips to total 48" and use these strips to finish the center edges of the tree skirt. Leave equal overhang on each end for ties. Turn under any raw edges and finish with a machine topstitch in matching-colored thread.

5.  Be sure to add a label!

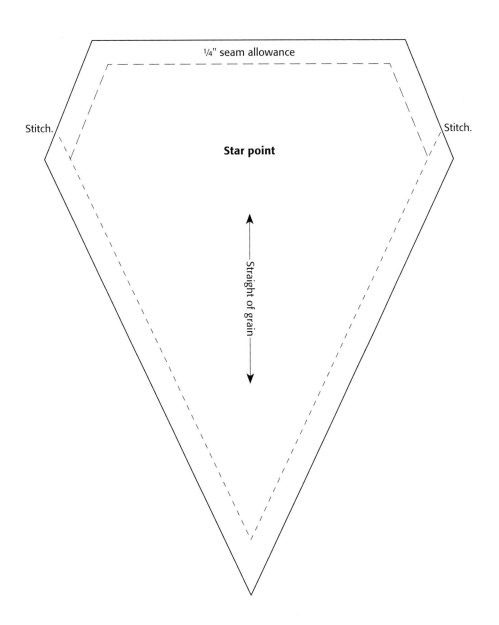

# How Far Is It to Bethlehem?

This lap quilt brings together favorite images of that wondrous trip to Bethlehem: the stars, the elegant travelers, and the camels. Gather the little ones in your family, cover them with this quilt, and read them stories of camels and traveling Wise Men.

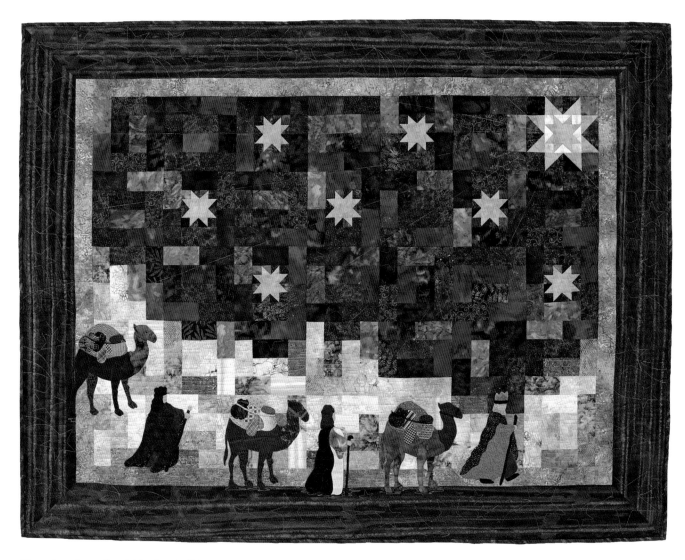

*Pieced and appliquéd by Rachel W. N. Brown, 55½" x 71½". Finished block size: 8" x 8".*
*Machine quilted by Lyon Den Quilting.*

## Materials

*All yardages are based on 40"-wide fabric unless noted otherwise.*

- 3¼ yards of multicolored batik stripe for outer border and binding*
- ½ yard of light brown mottled print for inner border
- ⅜ yard of gold print for Star blocks
- ¼ yard (or fat quarter) *each* of 8 different medium to dark blue prints for sky
- ⅛ yard (or fat eighth) *each* of 8 different light to medium brown prints for sand
- Fat eighth of very light gold print for large Star block
- 9" x 9" square *each* of 3 different browns for *each* camel appliqué (9 squares total; 1–8)
- 6" x 9" piece *each* of 3 coordinating fabrics for *each* Wise Man appliqué (9 pieces total. First Wise Man: 4–11, 13, and 14. Second Wise Man: 2, 5, 6, 7, 9, and 10. Third Wise Man: 3, 4, 5, 8, 9, 12, and 13.)
- 3" x 9" piece of wood-grain print for staff appliqués (1, 2, and 15; 3; and 6)
- 3" x 6" piece of tan fabric for Wise Men's face (12; 8; and 10) and hand (3; 1 and 4; and 7) appliqués
- 3" x 3" squares of 12 to 15 different scraps for camel bundle appliqués (9–14)
- Small scraps of black and gray prints for third Wise Man's shoes and beard (1, 2, and 11)
- 3¼ yards of fabric for backing
- 58" x 78" piece of batting
- 1½ yards of lightweight fusible web (optional)
- Black and gray embroidery floss
- Three black seed beads
- Assorted beads, small leather strips, tassels, and braided twine for embellishment (optional)

*A stripe that runs lengthwise works best.*

## Cutting

*Cut all strips across the width of the fabric (selvage to selvage) unless instructed otherwise.*

**From the assorted medium to dark blue prints, cut *a total of*:**
- 168 rectangles, 2½" x 4½"
- 28 squares, 1⅞" x 1⅞"
- 28 squares, 1½" x 1½"
- 4 squares, 2⅞" x 2⅞"
- 4 squares, 2½" x 2½"

*(Continued on next page)*

**From the assorted light to medium brown prints, cut *a total of:***
* 90 rectangles, 2½" x 4½"

**From the gold print, cut:**
* 4 squares, 2⅞" x 2⅞"
* 2 strips, 1⅞" x 40"; crosscut into 32 squares, 1⅞" x 1⅞"
* 1 strip, 2½" x 40"; crosscut into 8 squares, 2½" x 2½"

**From the very light gold print, cut:**
* 4 squares, 1⅞" x 1⅞"
* 4 squares, 1½" x 1½"

**From the light brown mottled print, cut:**
* 6 strips, 2" x 40"

**From the *lengthwise grain* of the multicolored batik stripe, cut:**
* 2 strips, 6½" x 60"
* 2 strips, 6½" x 76"

**From the remaining multicolored batik stripe, cut:**
* 2½"-wide bias strips to total 265"

## Making the Sky and Sand Blocks

YOU WILL NEED 27 Sky and Sand blocks for this quilt. All blocks are pieced the same way, but in different color variations. Mix and match the fabrics to make the blocks as scrappy as possible.

1. With right sides together, sew two 2½" x 4½" blue rectangles together as shown; press (fig. 1). Make 13.

2. Sew a 2½" x 4½" blue rectangle to opposite sides of each unit as shown: press (fig. 2). Make 13.

3. Sew two 2½" x 4½" blue rectangles together as shown; press (fig. 3). Make 26.

4. Sew a unit from step 2 between two units from step 3 as shown; press (fig. 4). Make 13 and label them block A (fig. 5).

5. Repeat steps 1–4 using 2½" x 4½" light brown rectangles. Make seven and label them block B (fig. 6).

Make 13.

**Fig. 1**

Make 13.

**Fig. 2**

Make 26.

**Fig. 3**

**Fig. 4**

Block A.
Make 13.

**Fig. 5**

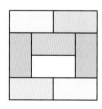

Block B.
Make 7.

**Fig. 6**

6. Repeat steps 1–4 using 2½" x 4½" blue and light brown rectangles to make the required number of blocks in each color arrangement. Label the blocks as shown below.

Block C.
Make 1.

Block D.
Make 2.

Block E.
Make 1.

Block F.
Make 1.

Block G.
Make 2.

## Making the Small Star Blocks

1. Refer to step 1 of "Piecing the Background" (page 67). Use 1⅞" gold and blue squares to make 56 half-square-triangle units, each 1½" x 1½" (fig. 7).

2. Sew two units from step 1 together as shown; press (fig. 8). Make 28.

3. Sew a 2½" gold square between two units from step 2 as shown; press (fig. 9). Make seven.

4. Sew each remaining unit from step 2 between two 1½" blue squares as shown; press (fig. 10). Make 14.

5. Sew each unit from step 3 between two units from step 4 as shown; press (fig. 11). Make seven.

6. Refer to "Making the Sky and Sand Blocks" steps 2–4 (page 78). Use a unit from step 5 and six 2½" x 4½" blue rectangles to complete a small Star block as shown (fig. 12). Make seven.

Make 56.

**Fig. 7**

Make 28.

**Fig. 8**

Make 7.

**Fig. 9**

Make 14.

**Fig. 10**

Make 7.

**Fig. 11**

Small Star (SS).
Make 7.

**Fig. 12**

## Making the Large Star Block

1. Refer to "Making the Small Star Blocks" steps 1–5 (page 79). Make one small Star block, substituting four 1⅞" and four 1½" light gold squares for the four 1⅞" and four 1½" blue squares (fig. 13).

2. Refer to step 1 of "Piecing the Background" (page 67). Use 2⅞" gold and blue squares to make eight half-square-triangle units, each 2½" x 2½" (fig. 14).

3. Sew two units from step 2 together as shown; press (fig. 15). Make four.

4. Sew the unit from step 1 between two units from step 3 as shown; press (fig. 16).

5. Sew each remaining unit from step 3 between two 2½" blue squares as shown; press (fig. 17). Make two.

6. Sew the unit from step 4 between the units from step 5 to complete one large Star block as shown; press (fig. 18).

| Make 1. | Make 8. | Make 4. | | Make 2. | Large Star (LS) |
|:---:|:---:|:---:|:---:|:---:|:---:|
| **Fig. 13** | **Fig. 14** | **Fig. 15** | **Fig. 16** | **Fig. 17** | **Fig. 18** |

## Assembling the Quilt

REFER TO THE photo (page 76) and the diagram at right. Place blocks A–G and the small and large Star blocks in five horizontal rows of seven blocks each, making sure the blocks are oriented as shown. Press the seams in opposite directions from row to row. Sew the rows together; press.

## Adding the Borders

1. Sew the 2"-wide light brown border strips together end to end to make one continuous strip. Refer to "Squared Borders" (page 12) as needed to measure, trim, pin, and sew the inner-border strips to the sides, top, and bottom of the quilt.

2. Refer to "Mitered Borders" (page 13) as needed to measure, pin, and sew 6½" x 60" multicolored outer-border strips to the sides and 6½" x 76" multicolored strips to the top and bottom of the quilt. Miter the corners (fig. 19).

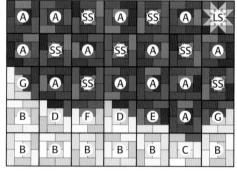

Quilt assembly

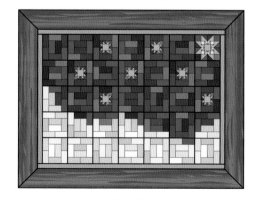

**Fig. 19**

## Adding the Appliqués

Refer to "Appliqué Techniques" (page 7) for guidance as needed. Patterns for the three standing Wise Men and the camel appear on pages 82–83. These patterns are a different size than those used for "The Adoration."

1. Use your preferred method to prepare the appliqué pieces for the three Wise Men and three camels. Working in numerical order, position and appliqué the pieces to the pieced background. Notice that the camels and the figure of Balthazar overlap the outer border.

2. Refer to "Embroidery Stitches" (page 12) and to the appliqué patterns. Use the black and gray embroidery floss and a backstitch or outline stitch to add rope to the camels. Use a black seed bead for each camel's eye.

## Finishing

Refer to "Finishing Your Quilt" (page 14) as needed to complete your lap quilt.

1. Layer the backing, batting, and top; baste.

2. Quilt as you prefer.

3. Use the 2½"-wide multicolored bias strips to bind the edges of the quilt.

4. Add additional embellishment to the figures as desired: add leather halters to the camels, beading to decorate the Wise Men, and so on.

5. Be sure to add a label!

### Three Wise Men: Door Quilt

Greet your holiday visitors with an elegant door quilt—another way to showcase the Magi blocks (blocks 7, 8, and 9 on pages 41, 44, and 47) from "The Adoration." Notice that Dianne reversed the figures in the 10" x 10" (finished) on-point blocks.

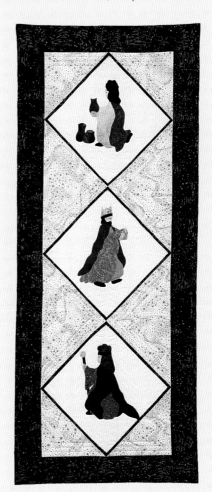

*Pieced, appliquéd, and quilted by Dianne Louvet, 19" x 47"*

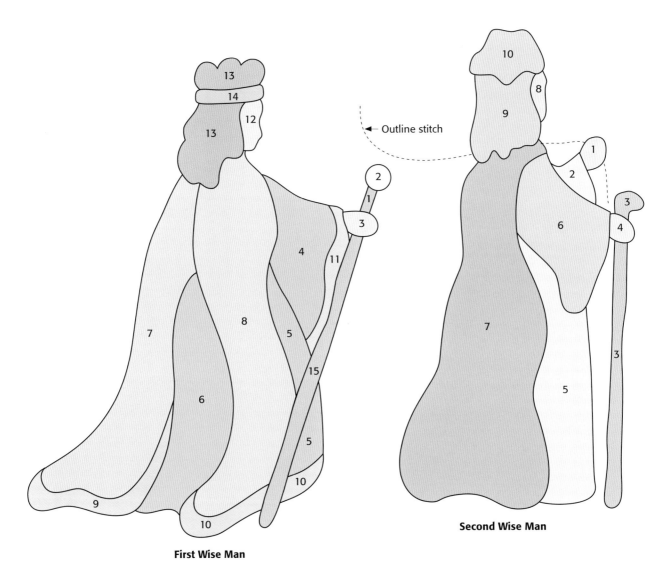

← Outline stitch

**First Wise Man**

**Second Wise Man**

Enlarge patterns 200%.
Appliqué pattern pieces do not
include seam allowances.
Reverse for fusible appliqué.

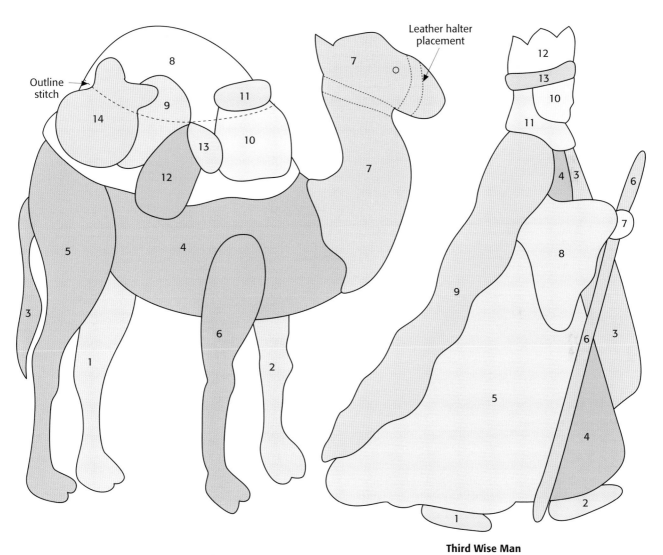

Leather halter placement

Outline stitch

**Third Wise Man**

Enlarge patterns 200%.
Appliqué pattern pieces do not
include seam allowances.
Reverse for fusible appliqué.

# Gathered at His Manger Bed

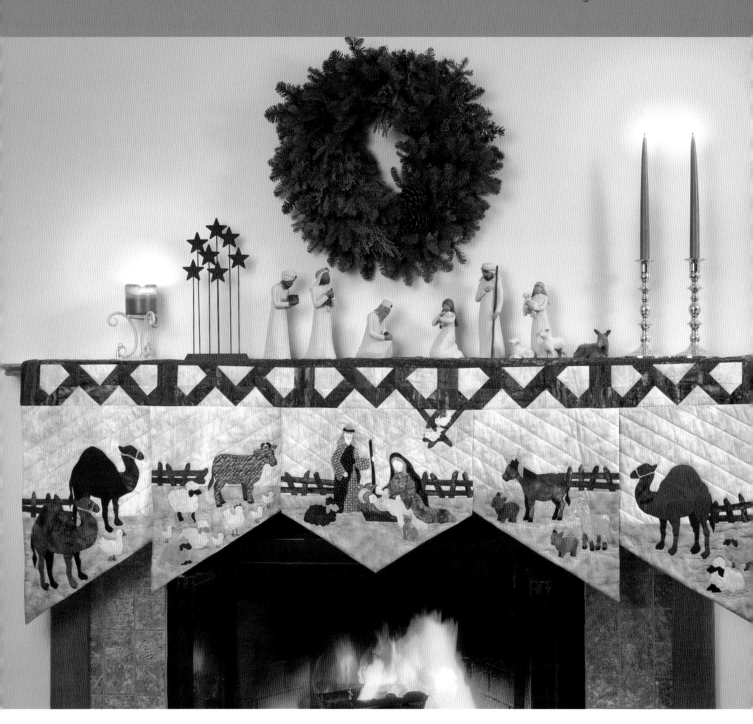

*Made and quilted by Rachel W. N. Brown
and Susan Shiflet, 37½" x 72"*

This unusual mantel quilt was inspired by the little book Who Is Coming to Our House? (see "Recommended Reading" on page 94). The only humans in the illustrations are Mary, Joseph, and the Christ child. Feel free to add as many animals as you want to the group that welcomed the infant Jesus to their stable home.

In addition to mantel display, this quilt may also be used in the narthex or chancel area of your church. Many communion tables in the chancel measure 72".

## Materials

*All yardages are based on 40"-wide fabric. Fabric requirements for Joseph, Mary, and the child appear on pages 56–57.*

Yardages are given for a mantel that is 72" long and 9" deep. The panels overlap a bit, so the pattern is easily adjusted in small increments. However, if your mantel is longer than 80", you'll need to add the necessary inches to the width of the panels.

Background

- 1⅞ yards of brown wood-grain print for rafters, top border, fences, and dove perch (1–5)
- 1⅛ yards of light blue mottled batik for sky
- ⅔ yard of gold print for straw

Camels (3)

- 3 different 3" x 5" pieces of contrasting brown print for legs and tails (1, 2, and 3)
- 3 different 6" x 9" pieces of contrasting brown print for bodies and legs (4, 5, and 6)
- 3 different 3" x 6" pieces of medium brown print for heads (7)

Goose

- 3" x 3" square of orange print for feet and beak (1, 2, and 3)
- 3" x 3" square of white tone-on-tone print for body (5)
- 2" x 3" piece of very light gray tone-on-tone print for wings (4 and 6)

Cow

- 3" x 3" square of dark brown print for hooves and horns (1–4, 9, and 11)
- 3" x 5" piece of medium-dark brown print for legs and tail (5–7)
- 6" x 9" piece of medium brown print for body and head (8 and 10)

*(Continued on next page)*

Kneeling Sheep (4)

- 4 different 2" x 2" squares of medium to dark gray for legs, faces, and ears (1, 2, 3, and 5)
- 4 different 4" x 4" squares of light to medium gray print for bodies and heads (4 and 6)

Standing Sheep (2)

- 4" x 4" square of black fabric for legs, faces, and ears (1, 2, 6, and 7)
- 2 different 2" x 2" squares of medium gray print for legs (3 and 4)
- 2 different 4" x 4" squares of light gray print for bodies and heads (5 and 8)

Hen (1) and Chicks (4)

- Small scrap of red fabric for hen's comb (1)
- Small scrap of orange fabric for hen's beak (2)
- 3" x 3" square of white-on-white print for hen's body (3 and 4)
- 1" x 2" piece of very light tone-on-tone print for hen's wing (5)
- 2" x 7" piece of light yellow for chicks

Cat

- 3" x 3" square of gray print for body (1)
- 4" x 4" square of coordinating gray print for haunch, legs, and head (2, 3, and 5)
- 2" x 2" square of pink print for ears (4 and 6)

Doves (2)

- 2 different 2" x 3" pieces of white-on-beige print for bodies (1, 3, and 4)
- Small orange scraps for beaks (2)

Donkey

- 3" x 3" square of black fabric for hooves (1, 3, 4, and 6)
- 3" x 4" piece of dark gray print for legs, tail, and mane (2, 5, 7, 9, and 12)
- 6" x 7" piece of medium gray print for body and head (8 and 10)
- 2" x 3" piece of light gray print for ears (11 and 13)

Goat

- Small scrap of black fabric for hooves (1–4)
- 2" x 3" piece of dark gray print for legs (5–9)
- 5" x 5" square of medium gray print for body, upper leg, ear, and head (10, 11, 13, and 15)
- Small scrap of white fabric for inner ears and tail (12, 14, and 16)
- Small scrap of brown fabric for horns (17 and 18)

Pigs (2)

- 2 different 2" x 2" squares of dark rust print for legs and ears (1, 2, and 4)
- 2 different 4" x 4" squares of medium rust print for bodies and head (3 and 5)

Finishing

- 3 yards of fabric for backing
- 2 packages, 45" x 54", of Thermore or other very lightweight batting

## Create an Advent Tradition

The mantel quilt has five sections. At the end of this book is a "Recommended Reading" list (page 94) of the books that I mention in these pages. Choose five books that relate directly to the animals in the stable. On each Sunday of Advent, sit with your family, light a candle, and read a story. Even if your children are grown, you can still indulge yourself with the memories of time gone by. You may have a collection of Christmas books, long forgotten because there are no longer little ones around. This is the year to get those books out and read them again—for the child that remains in all of us.

Miscellaneous

- 1½ yards of lightweight fusible web
- Freezer paper
- 24" ruler and pencil
- Narrow leather strips
- Embroidery floss in various colors (brown, rust, yellow, orange, white, and gray)
- Black embroidery floss *or* black Pigma pen

## Cutting

*Cut all strips across the width of the fabric (selvage to selvage) unless instructed otherwise.*

### From the *lengthwise grain* of the brown wood-grain print, cut:
- 2 strips, 8½" x 38"
- 3 strips, 4" x 28"

### From the remaining brown wood-grain print, cut:
- 5 squares, 3¼" x 3¼"
- 25 squares, 2⅞" x 2⅞"
- 4 rectangles, 2½" x 4½"
- 2 rectangles, 2½" x 8"
- 1 rectangle, 8" x 18"

### From the light blue mottled batik, cut:
- 5 squares, 3¼" x 3¼"
- 2 strips, 2⅞" x 40"; crosscut into 15 squares, 2⅞" x 2⅞"
- 1 strip, 2½" x 40"; crosscut into 10 squares, 2½" x 2½"
- 1 strip, 15" x 40"; crosscut into:
  - 2 rectangles, 11" x 15"
  - 2 rectangles, 8" x 15"
- 1 rectangle, 8½" x 19"

### From the gold print cut:
- 2 rectangles, 13" x 15"
- 1 rectangle, 8" x 19"

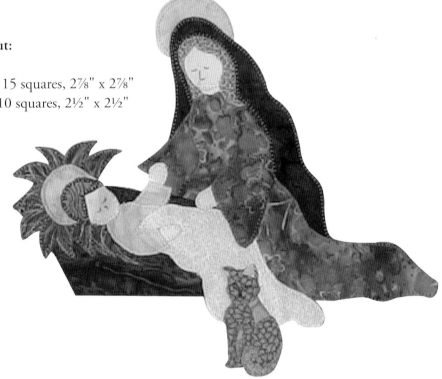

## Making the Rafters

1. Use the 3¼" blue and wood-grain squares to make 10 half-square-triangle units (step 1, page 67), each 2⅞" x 2⅞" (fig. 1).

2. Draw a diagonal line on the wrong side of each unit, crossing the original seam as shown. Place each marked unit right sides together with a 2⅞" wood-grain square. Sew a scant ¼" on each side of the line. Cut on the drawn line (fig. 2). Make 20. (You'll have 10 of each mirror image.)

3. Use the 2⅞" blue squares and the remaining 2⅞" wood-grain squares to make 30 half-square-triangle units (fig. 3).

4. Join four units from step 2 (two of each mirror image), six half-square-triangle units from step 3, and two 2½" blue squares in two rows as shown. Press the seams in each row in opposite directions. Sew the rows together; press (fig. 4). The block should measure 4½" x 12½". Make five.

5. Join the units and the four 2½" x 4½" wood-grain rectangles, alternating them as shown; press (fig. 5).

6. Sew the three 4" x 28" wood-grain strips together with diagonal seams; press. Measure the length of the unit from step 5, cut the pieced strip to that measurement (centering the seams), and sew to the top of the unit; press (fig. 6).

7. Sew the 2½" x 8" wood-grain rectangles to opposite ends of the unit from step 6; press (fig. 7).

8. Sew the two 8½" x 38" wood-grain strips together to make a strip 8½" x 75½". Measure the length of the unit from step 7, cut the pieced strip to that measurement, and sew to the top of the unit; press (fig. 8).

9. Measure the unit from step 8 (top to bottom and side to side); add 2" to the top-to-bottom measurement. Cut and piece the backing to match these measurements. Cut the batting (piecing, if necessary) to match the backing. Layer the batting (on the bottom), the unit from step 8 (right side up), and the backing (wrong side up), aligning the top raw edges (fig. 9). The backing and batting will extend beyond the pieced bottom edge.

Make 10.

**Fig. 1**

Rafter corner blocks.
Make 20 (10 of each).

**Fig. 2**

Make 30.

**Fig. 3**

Make 5.

**Fig. 4**

**Fig. 5**

**Fig. 6**

**Fig. 7**

**Fig. 8**

10. Beginning 2" from the lower-left corner, sew around the perimeter of the layered unit with a ¼" seam. Stop sewing 2" from the lower-right corner, leaving the bottom edge open. Trim the corners, turn the unit right side out so the quilt top is right side up on the top layer, and press (fig. 10).

**Fig. 11**

11. Quilt as desired, leaving the bottom 2" unquilted until the entire piece is assembled.

## Making the Panels

Regular                    Reversed

**Fig. 12**

1. Place the 13" x 15" gold rectangles right sides together. Measure down 2" from the top on the left 13"-long edge, and up 2" from the bottom on the right 13"-long edge as shown. Use a ruler and pencil to draw a line connecting both points (fig. 11). Check your measurements again for accuracy, and then cut on the drawn line. You will have four pieces: two regular and two reversed (fig. 12).

2. Sew a regular piece from step 1 to the 15" edge of an 11" x 15" blue rectangle and the other regular piece to an 8" x 15" blue rectangle as shown. Press; label these panels *right* (fig. 13). Repeat with the reversed pieces; label these panels *left* (fig. 14).

Right panels

**Fig. 13**

3. Cut a piece of freezer paper 8" x 19". Measure down 2" from the top on each 8"-long side. Find the midpoint (9½") at the bottom edge; mark this point. Use a ruler and pencil to draw a line from each 2" mark to the midpoint as shown (fig. 15). Cut on the drawn line and discard the lower triangles. Use the remaining piece (fig. 16) as a template to cut the center panel from the 8" x 19" rectangle of gold fabric.

4. With right sides together, sew the piece from step 3 to the 8½" x 19" blue rectangle as shown; press (fig. 17).

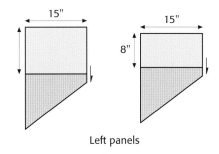

Left panels

**Fig. 14**

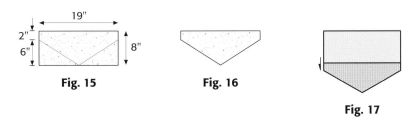

**Fig. 15**          **Fig. 16**

**Fig. 17**

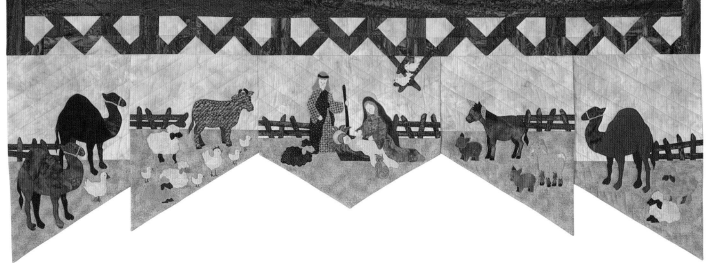

## Making and Appliquéing the Fences and Dove Perch

Refer to "Fusible Appliqué" (page 10) for guidance as needed. The dove perch pattern appears on page 93.

1. Iron a piece of fusible web to the wrong side of the 8" x 18" wood-grain rectangle. Cut the fused fabric into 36 strips, ½" x 6". Cut 24 fence posts and 12 crosspieces, roughly rounding the ends as shown in the photo (above). Set the remaining fused fabric aside.

2. Refer to the photo. Position and fuse a fence (two crosspieces and four fence posts from step 1) to each panel: a fence to the left edge of each left panel, a fence to the right edge of each right panel, and the remaining two fences to the right and left edges of the center panel. Position the fence posts randomly so they don't look exactly the same.

3. Repeat step 1 using the remaining fused wood-grain fabric and the pattern to cut pieces 1–5 for the dove perch. Refer to the photo to position and fuse the perch to the upper right of the center panel as shown.

4. Use your preferred stitch to finish the edges of all fence and dove perch appliqués before moving to the next step.

## Adding the Appliqués

Lay out the panels in the order shown, referring to "Appliqué Techniques" (page 7) as needed. For each panel, use your preferred method to prepare the appliqué pieces as follows; then position and appliqué the pieces in numerical order. All of the animal appliqué patterns are on page 93. Joseph, Mary, and the child are on page 59.

### Outer-Left Panel

**Patterns needed:** 2 camels (regular) and 1 goose.

Use the narrow leather strips for the halters on the camels. Referring to "Embroidery Stitches" (page 12), make French knots with black floss for the animals' eyes or mark them with a Pigma pen.

### Inner-Left Panel

**Patterns needed:** 1 cow, 1 standing sheep (reversed), 2 kneeling sheep (reversed), 1 hen, and 4 chicks.

Use embroidery floss and a backstitch or outline stitch to embroider the cow's facial features, legs on the hen and chicks, and beaks on the chicks. For the eyes, make French knots with black floss or mark them with a Pigma pen.

### Center Panel

**Patterns needed:** Joseph, Mary, and the child; 1 kneeling sheep (reversed); 1 cat; and 2 doves.

Use embroidery floss and a backstitch or outline stitch to embroider the cat's facial features and the feet on the doves. For the eyes, make French knots with black floss or mark them with a Pigma pen. Use embroidery or a Pigma pen to add facial features to the family.

### Inner-Right Panel

**Patterns needed:** 1 donkey, 1 goat, and 2 pigs.

Use embroidery floss and a backstitch or outline stitch to embroider the goat's facial features and the pigs' snouts and tails. For the eyes, make French knots with black floss or mark them with a Pigma pen.

**Fig. 18**

### Outer-Right Panel

**Patterns needed:** 1 camel (reversed), 1 standing sheep, and 1 kneeling sheep.

Use the narrow leather strips for the halter on the camel. For the animals' eyes, make French knots with black floss or mark them with a Pigma pen.

## Assembling the Panels

1. Place a panel right sides together on the backing fabric and cut a backing piece to match. Without separating the panel top and the backing, flip the layered unit over so the wrong side of the backing is face up and layer the stacked pieces on top of the batting. Cut a piece of batting, adding 1" to all sides; pin the three layers (fig. 18). Repeat for each panel.

2. Sew around the perimeter of each layered unit with a ¼" seam, leaving the top edge open (fig. 19). Trim the excess batting on the three stitched sides, turn each unit right side out so the panel top is right side up on the top layer, and press lightly. Stitch across the top edge of each panel with a narrow zigzag stitch (fig. 20).

3. Quilt each panel as you wish.

Leave open.

**Fig. 19**

**Fig. 20**

## Assembling and Finishing the Quilt

IF YOU HAVE a table or countertop large enough, lay the piece out to its full length.

1. Pin the backing fabric and batting out of the way on the wrong side of the rafter unit, leaving the pieced section free. Turn the unit right side up.

2. Arrange the panels along the bottom edge of the rafter piece, overlapping them approximately 1" on each side. Position the outermost panels in ¼" as shown (fig. 21).

3. With right sides together and raw edges aligned, turn the center panel up and pin it to the rafter unit. Pin-mark the position of the panels to the immediate left and right as shown. Turn these two panels up and pin them carefully in place (fig. 22). Repeat for the outermost panels.

4. Carefully stitch the panels in place with a ¼" seam. Press the long seam toward the rafter unit so the panel seam lies flat (fig. 23).

5. Unpin the extra fabric. Trim the batting so it abuts the batting in the panels and fills the unquilted space between the rafter unit and the panels.

6. Place the backing fabric over the seam. Trim the backing, leaving enough excess (approximately ½") to press under and cover the exposed seam; pin. Hand stitch in place (fig. 24).

7. Turn and hand stitch the remaining unstitched sides of the quilt.

8. Finish quilting the bottom edge of the rafter unit.

9. Place the quilt on the mantel. Hold it in place with T pins if necessary. Add candles, pottery jugs, small baskets, or a stack of old books. Sit back and enjoy the work of your hands.

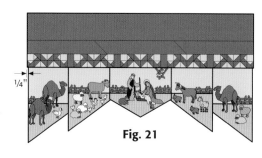

**Fig. 21**

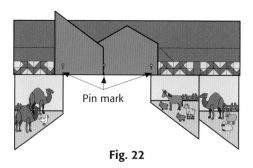

**Fig. 22**

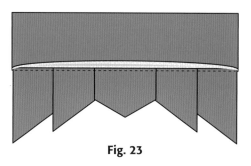

**Fig. 23**

**Fig. 24**

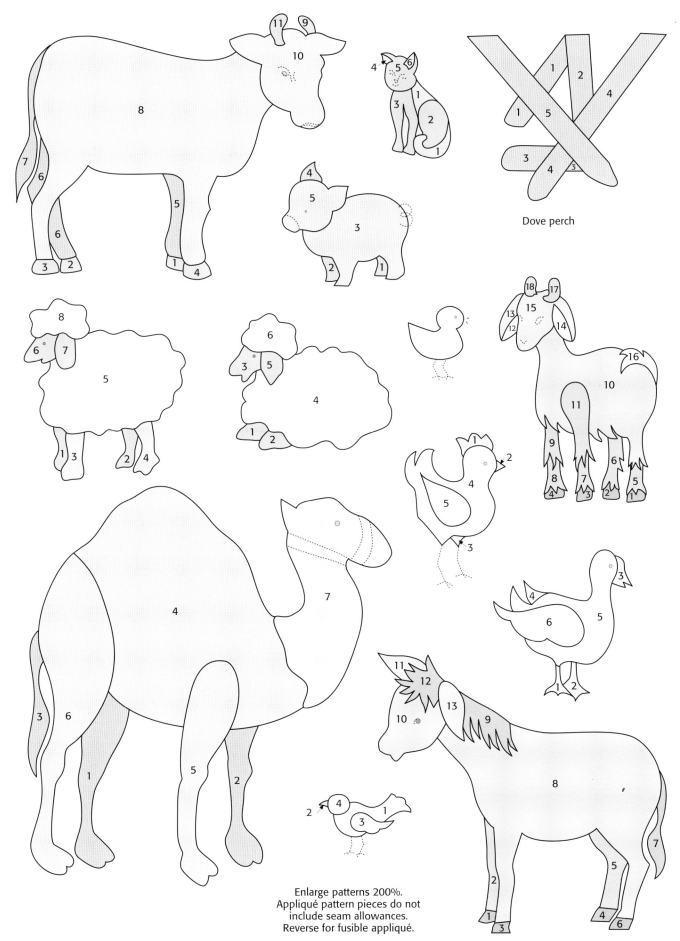

Dove perch

Enlarge patterns 200%.
Appliqué pattern pieces do not
include seam allowances.
Reverse for fusible appliqué.

# Recommended Reading

WHEN MOST OF this book had been written, with the patterns, yardages, instructions, recommended books, and information all included, one of my children asked, "Did you write about the first gift of Christmas?" No, I had not, and so I share it with you now. It is a tradition that has a life of its own.

I'm not a morning person, at least not in the traditional sense. I like to rise slowly and ease quietly into my day. Christmas morning with impatient little ones was a challenge. I didn't want to race out of bed, open all the presents, and then have the celebration be over. So when our children were quite small, I would hang stockings and wrap and hide the first gift of Christmas with all the presents under the tree the night before. The girls were allowed to get up as early as they wanted and open the gifts that were in their stockings. I always included something for them to do, and a small game they could play together. They were allowed to search for the first gift, but not open it. They were not supposed to wake us—although hearing squeals from the living room made it difficult to sleep. When the girls knew we were awake, they would bring us their stockings and treasures and the first gift of Christmas, still wrapped in its special paper and big bow. They would crawl into bed and snuggle between us. We would read the Christmas story from the Matthew and Luke gospels, and then open the special package. It was always a book, a children's Christmas book. We would read the book together, then get up, have coffee, juice, and cinnamon buns in the living room while we opened gifts, one at a time, most of the morning.

Early on, I chose books appropriate to their ages, but as they got older, they still liked the stories meant for younger children. As Dara Lynn neared her teen years, I thought the girls might think the ritual too silly. But in December 1982, Gregory was born. And soon after Thanksgiving, the girls asked me if I had found the book for the baby's first Christmas. The tradition continued.

The year that Greg turned 13, Dara Lynn had moved to Everett, Washington; Kay was engaged to Travis; and I thought the ritual would surely end. This time it was Greg who came to me and asked, "Have you found the first gift of Christmas yet?" So I headed to my favorite book shops to search. I thought this was the year we would all gather in the living room for the ritual.

On Christmas morning, Greg appeared at our bedroom door, his stocking and the first gift of Christmas in hand. Not far behind were Kay and Travis with pillows and mugs of coffee. They settled on the floor at the foot of our bed, Greg stretched himself across the end of the bed, and we read and laughed and cried together.

The tradition and the ritual continue, but now we gather in the living room and often read the book after we have opened gifts. Sometimes we save the first gift for the day that our extra daughter, Kristy, and her family—Steve, Brittany, and Rachel—are with us. Every year, a new book extends the ritual further into our lives. I hope you have traditions like this in your family, or are inspired to create some that are unique to your family.

Brown, Ruth. *The Shy Little Angel.* New York: Dutton Children's Books, 1998.

Clements, Andrew. *Bright Christmas: An Angel Remembers.* New York: Clarion Books, 1996.

Cooper, Susan. *Danny and the Kings.* New York: Maxwell Macmillan, 1993.

dePaola, Tomie. *The Story of the Three Wise Kings.* New York: G. P. Putnam's Sons, 1983.

Duncan, Beverly K. *Christmas in the Stable.* New York: Harcourt Brace & Co., 1996. *This book of selected poetry includes poems about the animals we would expect to find in the manger, as well as ladybugs, mice, bees, and a bat.*

Ginolfi, Arthur. *The Tiny Star.* Nashville, TN: Thomas Nelson, Inc., 1997.

Henry, O. *The Gift of the Magi and Other Stories.* New York: HarperCollins, 1997.

Holder, Mig. *The Fourth Wise Man.* Minneapolis, MN: Augsburg Fortress, 1993.

Hoover, Susan Bame. *Faith the Cow.* Elgin, IL: Brethren Press, 1995.

Hunt, Angela Elwell. *The Singing Shepherd.* Oxford, England: Lion Publishing, 1992. *This is a children's story about the escape to Egypt. It recounts the tale of a young shepherd boy who sang when he was afraid. Even though he had a terrible singing voice, he felt better when he sang, and in this story, his courage and his song helped the holy family get past the guarded gate of the town. The story teaches that each of us has a gift to share.*

Iguchi, Bunshu. *The Shepherd Boy's Christmas.* Valley Forge, PA: Judson Press, 1978.

Jones, Timothy K. *Celebration of Angels.* Nashville, TN: Thomas Nelson Publishers, 1994.

Lachner, Dorothea. *The Gift from Saint Nicholas.* New York: North South Books, 1995.

L'Engle, Madeleine. *Dance in the Desert.* New York: Farrar, Strauss, and Giroux, 1988.

Lucado, Max. *The Crippled Lamb.* Nashville, TN: Tomas Nelson, Inc., 1999.

Menotti, Gian Carlo. *Amahl and the Night Visitors.* New York: Morrow Junior Books, 1986.

Peterson, Eugene H. *The Message.* Colorado Springs, CO: Navpress, 1994. *This book translates the New Testament and the Psalms in contemporary language.*

Shepherd, J. Barrie. *Faces at the Manger.* Nashville, TN: Upper Room Books, 1992.

Slate, Joseph. *Who Is Coming to Our House?* New York: Putnam & Grosset Group, 1988. *This book is especially suitable for very small children. The illustrations by Ashley Wolff are delightful. This is a book you'll read over and over again with little ones, and not mind the repetition.*

Spang, Günter. *The Ox and the Donkey.* New York: North South Books, 2001.

Tazewell, Charles. *The Littlest Angel.* Nashville, TN: Ideals Children's Books, 1991.

Thury, Fredrick H. *The Last Straw.* Watertown, MA: Charlesbridge Publishing, 1998.

Visconti, Guido. *One Night in a Stable.* Grand Rapids, MI: Eerdmans Books for Young Readers, 2003.

Vivas, Julie. *The Nativity.* New York: Harcourt Brace & Company, 1988.

Ward, Helen. *The Animals' Christmas Carol.* Surry, England: Templar Publishing, 2001. *This book includes not only the traditional animals at the manger but also the lowly woodworm and the elegant peacock. It's a wonderful book, complete with beautiful illustrations.*

Weems, Ann. *Kneeling in Bethlehem.* Philadelphia: The Westminster Press, 1987.

Wensell, Ulises. *They Followed a Bright Star.* New York: G. P. Putnam's Sons, 1994.

Wildsmith, Brian. *A Christmas Story.* New York: Alfred A. Knopf, Inc., 1989.

## Peace to All: A House Blessing

You can use any of the appliqué patterns to create festive wall hangings.

This small quilt makes a wonderful piece to place above a doorway in your home. Hang it as a reminder that Christmas Day may pass, but the spirit of the holiday doesn't have to end. As the year goes by, there are things that we can do to help us carry what we love so much about the holiday season into the whole of the year.

This quilt doesn't need to come down after Christmas. Hang it over a doorway, in a place that you pass often. Let it remind you that the peace which was born at Christmas can live with us all year long.

*Made and quilted by Cathy Thornton, 22" x 36"*

# Resources

**Thangles**
PO Box 2266
Fond du Lac, WI 54936
www.thangles.com

**Triangles on a Roll**
Quilter's Ranch
1030 E. Baseline Road, Suite 178
Tempe, AZ 85283
www.quiltersranch.com

**The Angler 2**
Pam Bono Designs, Inc.
PO Box 659
Pagosa Springs, CO 81147
www.pambonodesigns.com

# Meet the Author

IN FIRST GRADE, Mrs. Ruth Kachel taught me to read. In third grade, Mrs. Naomi Bard taught me to write beautifully with my left hand. Mrs. Zoe Kauffman taught elementary school art, and it was with her guidance that I learned about color and proportion. When I reached senior high, my mind and my heart were opened to children's literature by Miss Mary Lee Forney.

At home, my mother, Anna Mary Neff, set up the Singer sewing machine in the kitchen, and tolerated the creative mess I made as I learned to sew. As a young seamstress, I sewed my own wardrobe, and later made dresses and play clothes for my own little daughters—until they learned to read designer labels. Reading, writing, drawing, and sewing all bring me special memories of my life's unique journey.

In 1972, I moved with my pastor husband to the Antioch Church of the Brethren in Franklin County, Virginia. There I was introduced to serious quilting. I learned to quilt first, and later learned to piece from books by noted quiltmaker Georgia Bonesteel. My first quilt was a Log Cabin, pieced with the scraps from my girls' play clothes. I used a yardstick to measure and scissors to cut the strips. Embarrassed because the quilt was 1" wider at the top than at the bottom, I put the top away and worked on smaller projects. Eventually the quilt top came back out of the chest and was quilted. That first quilt is now one of my favorites, and I haven't stopped quilting since. I love the craft and the art blended together in fabric and pattern. My ideas bud and bloom.

When I am not sewing, designing, or managing things at my quilt shop, I enjoy time spent on vacations at the beach, impromptu lunches with girlfriends, Tuesdays with my sister Merti, setting a beautiful table and preparing special meals for friends and family, and spring mornings spent writing in my favorite wicker chair on the front porch. My husband, Dennis, and I share our home in Mount Sidney, Virginia, with Jesse, a very loyal miniature schnauzer, and Gershwin and Zoey, two cats I rescued that sometimes rescue me.